CONTENTS

INTRODUCTION

WELCOME TO STICK SKETCH SCHOOL!

I'm your instructor, Stick Master Bill Attinger, professional cartoonist extraordinaire and lover of stick figures, cartoon characters, and *The Princess Bride* (of course). In this book, I'm going to take you on a fun, artistic journey into a Stick World Wonderland, where I'll share my cartooning tips and secrets with you. Not a trained artist? It totally doesn't matter! The best part about stick figures is that *anybody* can draw one. All you need are a few shortcuts and techniques to make your stick figures as expressive, personal, and dynamic as the examples included throughout this book.

SO WHAT IS A STICK FIGURE?

Sure, on the surface a stick figure looks like a simple drawing: a basic shape with a few lines and a circle head—a sketch that's so easy, even a caveman could draw it. But don't let this superficial description fool you. With stick figures, it's what's on the inside that counts, literally, because stick figures are the "skeletons" of the cartoon world. That's right! Before they become those colorful, ultra-sleek 3-D characters that you see in your favorite movies and comic books, cartoons are stick figures first. Many cartoonists and animators use stick figure wireframes to sketch out the look, shape, and pose of a character before they add details and color on top of them. So, as you learn to master the art of stick figure design, keep in mind that you're actually practicing the beginning stages of cartoon development. Pretty sweet, huh?

BECOMING A STICK FIGURE MASTER

So, how can you become a Stick Figure Master? Well, young stick artist, we've created several lessons to help you get there. As you journey through this book, keep in mind the following lessons that I've learned over the years, including:

SIMPLICITY. Life is like a stick figure. You can make it as simple or as complicated as you want. So, choose your path wisely and remember: Simple art can be just as effective as the fanciest art. In other words, it's not how many lines you draw, it's how you draw them that counts.

SELF-EXPRESSION. Creating stick figures is about expressing yourself through art. It's about talking with your stick designs instead of with your mouth. So, before you start drawing, think of the message you want to communicate. And then practice how to say it with your design.

LAUGHTER. The most important rule when drawing stick figures or cartoons is that you must be able to laugh at yourself...and at your art. Normally, if someone laughed at an artist's work, the artist would be greatly offended. But, a Stick Figure Master invites laughter as a positive sign that the art is doing its job. Art doesn't always need to be so serious, and it definitely doesn't need to be competitive. Keep it about having fun and spreading joy, and your art will go a long way.

YOUR AWAKENING

Every artist has what I like to call their "awakening;" in other words, a moment when they realize the path they'd like to follow with their work, and why that path is right for them. For me, mastering the art of the stick figure can best be explained as an awakening to the simplistic. I spent the last twenty-something years as a commercial artist in a highly competitive industry. Artists and designers would constantly compete over who could create the biggest ideas and the fanciest new designs. It was exhausting. Then one day I wondered, "Does an elaborate design really speak to people more than a simple one?" So, I set out to test this theory by creating a fun and silly collection of black and white stick figure paintings that I showcased on T-shirts and greetings cards. I sold these simple designs right next to all of the more elaborate and colorful ones. A few short months later, those stick figure designs turned out to be the most popular pieces I'd ever created, and they outshined and outsold many of the fancier and more detailed artworks. It turns out my theory was correct; simple art is just as effective (and in many cases, more effective) than the most elaborate pieces, and all I had to do was open my eyes and experiment a little. As a Stick Figure Master, I advise you to follow your heart, find your niche, and discover your own awakening.

WHAT YOU NEED TO GET STARTED

So, are you ready to dedicate yourself to becoming a Master of the Stick Figure Arts? Great! Grab something to create your art with, and let's go! Many of the designs that I created for this book were developed with acrylic paint and ink using paintbrushes and markers. So, feel free to use those same elements if you want to emulate the same rough look and thickness of my artwork. But don't be afraid to find your own style and experiment with other mediums, like pens, pencils, markers, crayons, chalk, a paintbrush, or even finger paint. You can't go wrong with any of those, and it's fun to experiment with new tools. Plus, by experimenting with different mediums, you could end up crafting a super personal and distinct art style that people recognize as yours. There's nothing wrong with that!

THE ANATOMY OF THE STICK FIGURE

Dissecting Stick Figure Design

Few things are as simple and easy to draw as the stick figure, but how can you make your stick figures effective at conveying a message? In order to answer that question, we're going to break down the stick figure design, piece by piece. As we look deeper, we'll try to identify the purpose behind the creation of each and every limb and suggest appropriate techniques that might help you identify your style. Yes, dissection sounds painful, but don't worry, stick figures are very flexible, so it shouldn't hurt a bit!

Let's break down the stick figure design into specific steps and lessons.

CHOOSE THE RIGHT BODY TYPE
Shaping Up Your Stick Figure

Choosing a body type for your stick figure depends on what the occasion is. Is your stick figure attending a sporting event, participating in a beauty pageant, or going to war? Whether it's short or tall, thin or wide, you can usually give any character a solid foundation by using one of these three suggestions for the body: an oval, a triangle, or a line.

Ovals are great for showing size and strength, especially if you are trying to portray a larger character, like a football player, a wrestler, or even a monster. Ovals also provide a great space in which to add details to the body, like clothing, jewelry, and accessories, which work well if you are creating a uniformed character like a police officer, fireman, etc. (see page 24).

Triangles have always been a traditionally great shape for quickly identifying female characters, especially on restroom doors. But hey, this isn't your grandma's stick world! Today's stick girls are hip to wear anything they want, and a triangle can sometimes be very restrictive when it comes to creating fun poses. So, feel free to explore the triangle-shaped torso for your girl characters, but just don't get stuck in the Stickmuda Triangle.

Finally, there is the infamous stick line torso. When it comes to portraying thin, nothing beats a single-line stick body. However, this shape is more than just a quick fix; it also provides the most artistic freedom to create action, movement, and poses. If your stick figure is going to be on the move or striking a pose, then it's a stick body you want.

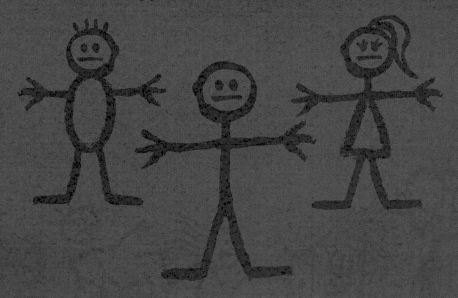

STICK
SKETCH SCHOOL
LESSON

Ready to get in shape? Try creating stick figure characters using some of the different body shapes. How do they impact the look and feel of your stick character? Can you think of other random shapes that might work for your characters, too?

GOING OUT ON A LIMB
Arming Your Stick Figure to Stand on Two Legs

Okay, so now that you've got some different bodies for your stick figure, ask yourself, what is my stick figure doing? Any action or lack of action will be portrayed in the stick figure's legs and arms. Is my stick figure running, jumping, standing, posing, or flying? Whatever they're doing, the stick figure's arms and legs are the key ingredients to illustrating both body language and emotion or feeling: arms crossed to show stubbornness; arms up to show confusion; legs crossed while seated to show relaxation. All of these things need to be considered when adding appendages to your subject. Let's review some examples below.

STICK
SKETCH SCHOOL
LESSON

Is your subject ready to take a stand? Let's build on the stick figures in Lesson 1 and add some arms and legs that will best match the stick subject you are envisioning. Try some action poses that would represent running, jumping, or dancing. Then try to portray some emotions. Make sure to play with some crazy combinations like a tall body with short arms or long arms on a short body.

HANDY THINGS TO CONSIDER WHEN MAKING FEET
How to Wait on Your Stick Figure Design Hand and Foot

We've already discussed the importance of using arms and legs to express action and emotion. But did you realize that hands and feet are just as important in expressing body language? Despite their importance, they are frequently omitted in stick figure art. Whether it's a six-fingered hand, a fist full of anger, or a fully detailed pair of spiked cleats, creating the right hands and feet can be just the detail to put your stick character ahead of the pack.

As you will see below, some characters do great with simple stick fingers and toes, especially in action poses where the hands are empty and you are not looking to draw attention to the hands and feet. However, if you are looking to arm your stick figure with something like a tool, a ball, or a weapon, then an oval-shaped balled-hand may be a more suitable choice, since the oval shape does a great job of simulating a fist. Of course, those aren't the only options. You could always choose to dress up your stick figures with specialized hands and/or feet if you wanted to really draw attention to them as a themed element.

STICK
SKETCH SCHOOL
LESSON

Now using your own characters, take the hands-on approach and try varying the styles of hands and feet. Do you prefer more detailed or simpler hands? Feel free to get creative with your appendages, like adding a giant "Number 1" finger, a large baseball glove, combat boots on a soldier, or whatever comes to mind.

GETTING A HEAD OF YOUR STICK SUBJECT
The Hairy Decision of Head Shapes

Now it's time to get ahead, so to speak. Yes, we're talking about your stick figure's literal head. The look, style, and shape you choose for your stick's noggin will say a lot about their character. For example, a large, round head could communicate that the stick figure appears "chunky," while a thinner, oval-shaped head might be more appropriate for a skinnier character. Slanting an oval head is a great way to portray action or movement in a particular direction. But no matter what head shape you choose, nothing will put your character over the top, better than what YOU put on top of it. Of course, I am talking about hair!

Hairstyles say a lot about a person, and they say a lot about stick figures, too! Unique hairstyles can really spice up a stick figure and are essential tools for portraying unique traits and personalities. Using the right hair and hair accessories can also be a great way to identify age, era, occupation, gender, and even origin. So whether you're rockin' a Mohawk, pigtails, or a geeky bowl cut, your stick figure's head and hair will be essential parts of your character's story. Check out some of the unique hairstyles on the stick figures below and see what they tell you about each character.

STICK
SKETCH SCHOOL
LESSON

Now it's time to put a lid on your stick subject. Try creating some stick figures featuring different head shapes, hairstyles, and head accessories that best fit the personality of the stick character you want to portray. If you've got stick block and nothing's coming to your head, literally, try illustrating people you know, like family, friends or even your favorite movie stars and athletes. Observe how the head and hair can really give an identity to an otherwise plain and unrecognizable stick figure.

THE FACE CASE
Not Just a Waste of Space

It's a face-off, err, rather, face-on, as we finally take a glimpse into your stick figure's psyche. The eyes might be the window to the soul, but a stick face can reveal more about its character than a gossip columnist could ever dream of! Take a good look at the faces featured on the stick figures below. What are they thinking? What are they feeling? How can you tell? Is it in their eyes? Mouth? Eyebrows? All of the above? You see, your stick character can turn from Crazy Mary to Saint Mary, depending on how you illustrate her face.

STICK
SKETCH SCHOOL
LESSON

Now let's face it! Practice drawing stick figures facing different situations that invoke emotion. What is going on with your stick figure? Did he just walk into the wrong bathroom at a restaurant? Perhaps he just saw his ex with his best friend? Or maybe your stick figure's team just won a huge game? Draw what that looks like!

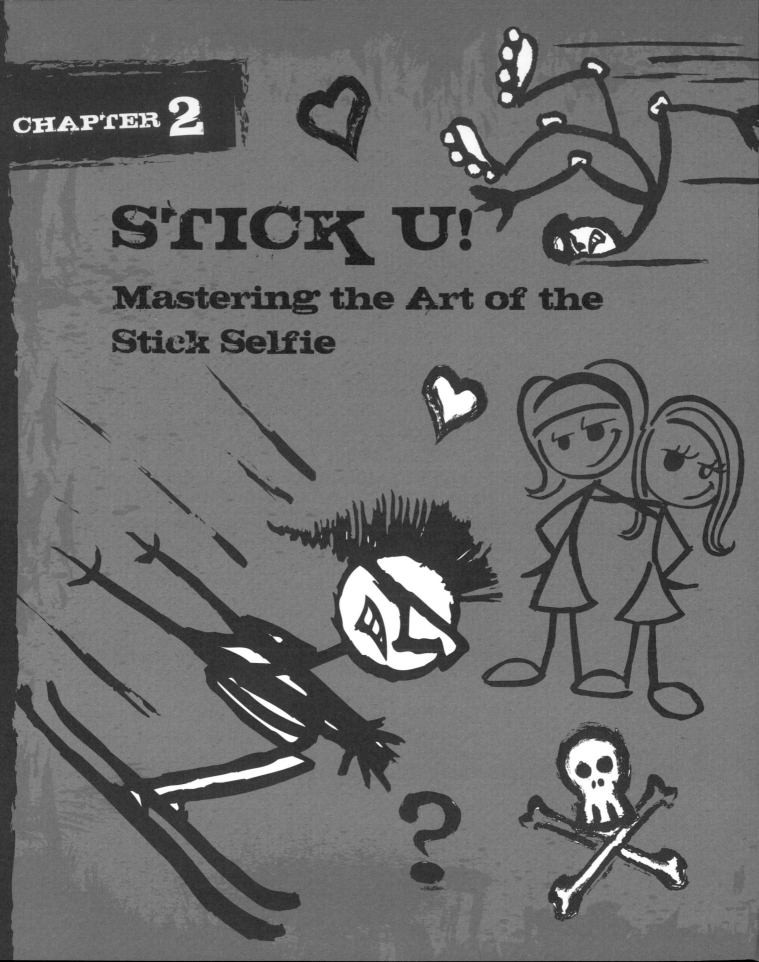

STICK U!

Mastering the Art of the Stick Selfie

When considering the study of the portrait, it's important to remember that age-old adage that if you can't love yourself, who can you love? The same goes for sketching. You should learn to draw yourself before you draw others because those first few drafts are not always pretty. And it's not very wise to try out new skills when you're creating portraits of loved ones if you want to keep your relationships intact. Take a look at Pablo Picasso's portraits and it's easy to understand why he experienced such rocky relationships with women. Would you want to be portrayed like that? Lesson learned!

In this chapter, we will review how to draw a stick selfie and a stick portrait. You'll discover the best ways to express gender identity and personality with hairstyle, fashion, action, and accessories in the stick world. By combining a familiar blend of personality characteristics with amusement park caricatures, we will explore methods of stick figure self-expression. After each lesson, read the creative prompt and try your hand at sketching a few selfies. Then, once you feel comfortable with sketches of yourself, feel free to explore the creation of stick masterpieces for your friends and family following these simple steps to sticky human nature. Each lesson in this chapter builds on the previous one. Once you complete the six lessons, you should be able to sketch your very own stick selfie with simple but identifiable features.

GENDER IDENTITY
Expressing Gender in Stick Figures While Keeping It Clean

In the real world, stereotyping and profiling are frowned upon. But in the stick world, stereotypes rule, as they provide visual clues that help make it easier to identify the gender of your stick figure! For example, some artistic details like eyelashes, facial hair, hairstyles, body shape, clothing, and accessories can be closely associated with specific genders in pop culture. Let's review a few examples below.

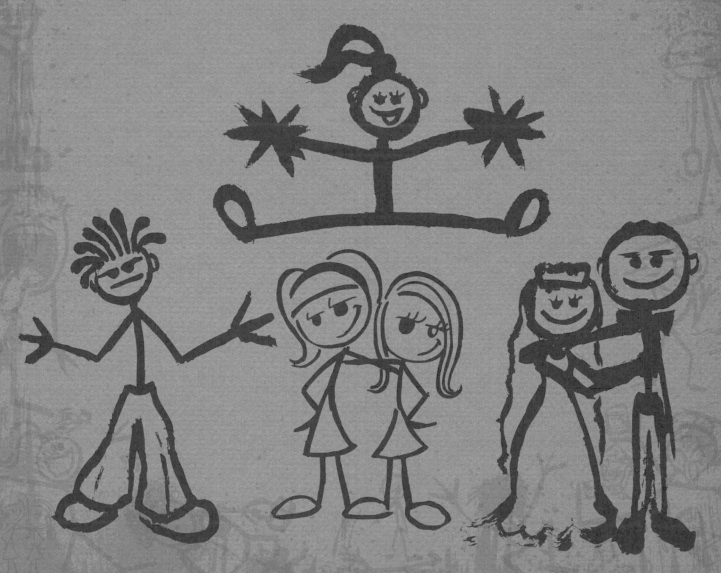

STICK
SKETCH SCHOOL
LESSON

Now try drawing a stick selfie using some stereotypical details to identify gender. If you're female, give yourself some eyelashes, lips, and maybe even a triangle skirt. Next, try some hairstyles. Perhaps you're a ponytail kind of gal! Now, if you're a dude, figure out what makes you stand out in a crowd. Is it your spiky hair and soul patch? Or your shaved head and goatee? The key is to hone in on something that will immediately identify you as a guy or a girl, knowing that it may not necessarily be just one thing, but a combination of several.

THE PERSONALITY TEST
Conveying Your Personality
through Stick Figures

So, what are you like? What do other people think about you? And we're not talkin' about your momma here! We're talking about real people who will give it to you straight. Perhaps you're outgoing and energetic? Flirty? Happy? Shy and reserved? Grouchy? Or maybe you're just a total geek! Whatever personality type you want to convey—be it truthful or not—body poses and facial expressions are key to capturing your personality in the stick world. For example, if you're grouchy, your face could have a frown and your arms might be crossed. Or if you're outgoing, your arms might be open wide and you could have a huge, inviting smile on your face. Check out some of these examples below for inspiration. Can you tell what types of personalities these stick people have?

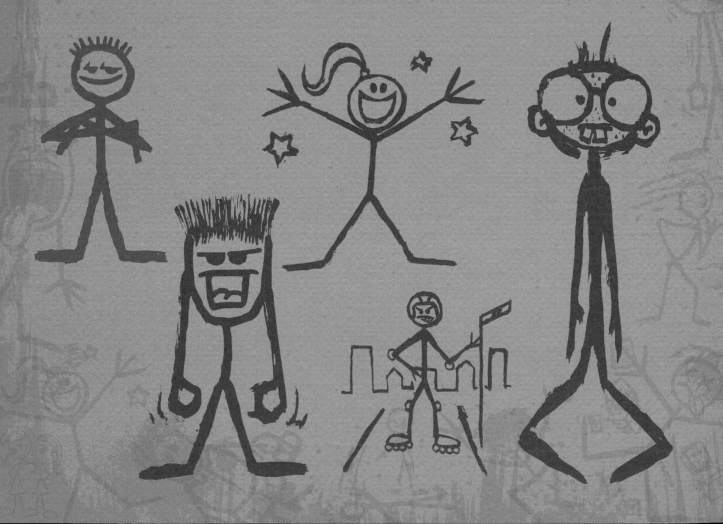

STICK
SKETCH SCHOOL
LESSON

Let's practice drawing some stick figures with different body poses and facial expressions. Before you start, think about what specific personality type(s) you want to convey in your stick figure. If a friend had to describe you in a certain pose, which pose would they choose for you? Would your nose be buried in a book? Would you be hamming it up for a camera? Or would you have your hands on your hips? You may even want to stand in front of a mirror and strike a pose to get yourself started. Go ahead and give it a shot! Just be prepared. If someone walks in on you, you're going to have to answer some serious questions as to why you are modeling for yourself in the mirror.

HAIR AND THERE
How Hair Expresses More than Style

Whether you're sportin' a comb-over, blinded by your "emo" bangs, or poking people in the eye with your liberty spike Mohawk, hair can say a lot about you. It can suggest an attitude, or identify your age, race, religion, and even a musical preference. Obviously there are lots of great hairstyles to choose from, and even if you give your stick figure a bad haircut, it's not an issue! You can grow the hair back in a matter of seconds with your pencil and you can shorten those giant feathered locks with a slight brush of your eraser. So, don't be afraid to experiment.

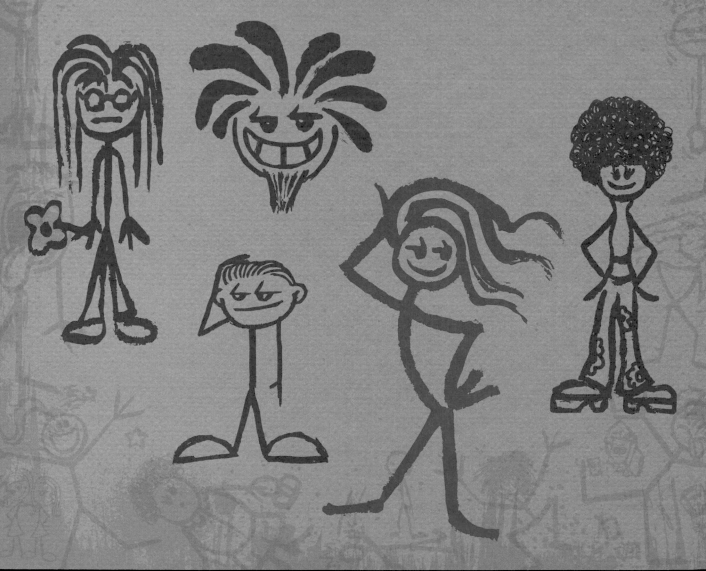

STICK
SKETCH SCHOOL
LESSON

Let's get hairy and practice some stick hairstyles. Try long beautiful hair! Short spiky hair! Giant curly afros! Ever-flowing dreadlocks! Or all of the above! Try drawing a stick selfie with some different hairstyles and then see how they change the perception of who you are.

DRESS FOR SUCCESS
Expressing Personal Identity with Clothing

It's what's on the inside that counts, right? Yeah whoever said that probably never walked down a dark alley and bumped into a large, unshaved guy in a leather motorcycle vest and steel-tipped boots. He might be warm and fuzzy, but you're not sticking around to find out! Sure, while the inside may ultimately be what matters most, the outside can give you a glimpse of what you might expect to find on the inside. In that regard, clothing can be an important part of telling your "inside" story. It acts as sort of a life uniform. And that uniform can say so much about you—your age, your attitude, your passions, and more.

So, what does your life "uniform" look like and how can you draw it? Is it an obvious uniform that you wear on the job, like a police uniform where you'd draw a badge on the chest? Or maybe it's a nurse's uniform with a medical cross on the hat. Of course, it could be an implied uniform based on your passions and hobbies, like a sports fan who wears his favorite team's jersey, a cowgirl sporting a cowboy hat, or a beach bum who sports sweet shades and a pair of beach shorts. Drawing the right clothing can really give your stick figure the personal identity you're looking for. Check out some of these dressed up characters below. What does their outfit tell you about them?

STICK
SKETCH SCHOOL
LESSON

Okay, it's time to hit the catwalk! Try drawing yourself with some different outfits and "uniforms." Consider your interests and passions as you outfit your stick selfie in different looks and styles.

ACTIONS SPEAK LOUDER THAN WORDS

How Activities Help Express Who You Are

Here is where we take a page from the good old caricature artist whom you sometimes catch on city streets or at amusement parks. You probably had one of these funny illustrations done at some point in your life. The artist draws a big face of you and a little body doing some activity you enjoy, like shopping, bike riding, playing soccer, or singing. You get the picture. These "activity poses" serve to tell the story about who you are and what you enjoy. For example, the activity could be your favorite sport or hobby, or your job or career. Take a look at some of the examples below and see if anything inspires you. Who knows, maybe you'll be inspired enough to make some important career decisions.

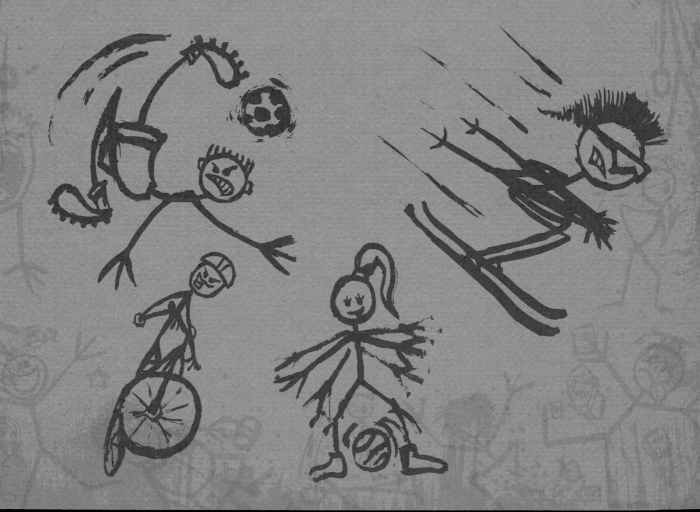

STICK
SKETCH SCHOOL
LESSON

Are you ready to jump into action? Let's put you and your stick selfie in motion by illustrating some activities you enjoy or your career of choice. Maybe you love basketball, jogging, or yoga. Perhaps you aspire to be a chef, an artist, singer, or musician. Practice illustrating the actions you might perform doing what you love.

ACCESSORIZE, ACCESSORIZE, ACCESSORIZE!

Making the Little Things Matter

Accessories. Whether they're jewelry, bags, shoes, or glasses, we all use them to complete our looks. If you're a jock, accessories can be your gear, your ball, or your equipment. And in your occupation, your work tools—be it a drill or a paintbrush—can complete your outfit. An accessory can mean the difference between some guy in a white coat and a doctor using his stethoscope. But, in the stick world, we're talking about more than just fashion. Accessorizing your stick figure with fun details goes a long way toward accurately portraying moods, feelings, and personality. Stick accessories can include the infamous floating hearts showing love, the floating tweety birds to convey drowsiness, or the floating dollar signs to illustrate ambition or greed. Whatever you decide to use, accessories are an essential part of the stick story. Let's review some examples below and find the finishing touches for your stick portraits.

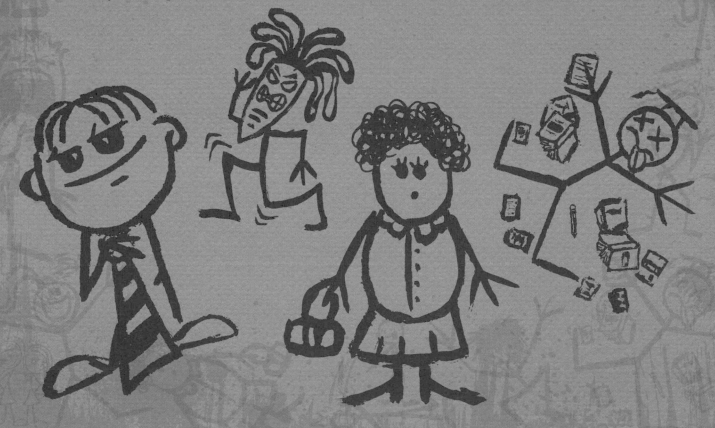

STICK
SKETCH SCHOOL
LESSON

So, you've got your stick selfie! Great job! Now it's time to put on the finishing touches. Go ahead and identify some accessories that tie in with your current look and sprinkle them on and around your stick figure! For example, if you work at McDonald's, add your uniform and nametag to your selfie and throw a burger and fries in the illustration for good measure. If you love soccer, maybe draw yourself in a pair of shorts and cleats holding a soccer ball. Get it?

CHAPTER 3

BODY LANGUAGE

Let Your Stick Bodies Do the 'Talkin'

The most effective stick figures can speak volumes without uttering a single word. They display their voice just by the way they look and pose. So, now that you've become familiar with the parts of the stick body, it's time to let your stick bodies do the talking!

Stick figures can be moody, expressive, and rowdy. They have a lot to say, but not always a lot of detail or space to say it. In this chapter, we'll explore the art of conveying some different attitudes using simple and subtle body poses. As we look at these different poses, we'll also practice the art of "reading between the lines" by trying to interpret what messages the poses are trying to convey. In each lesson, you'll have the opportunity to write captions or thought bubbles for stick figures displaying a variety of messages through body language.

Okay, are you ready? Let's start your crash course in stick figure body language.

COPPING AN ATTITUDE
How a Little Attitude Can Go a Long Way

Whether sweet or sassy, stick figures just love to show off their attitude! It's in their nature. And as you draw them, they can express your attitude, too!

So what does your attitude look like? Whatever it might be, it can be expressed in many different forms of stick body language. It can be a simple show of confidence, perhaps by standing tall and proud with chin up and a confident smile. Or it can take on a sarcastic feel with a roll of the eyes or a crossing of the arms. And if you really want to turn up the heat, try a tough face with an indignant look and the back turned away! Now that's what we refer to as some serious rude-a-tude! Talk to the hand because this stick is in your face!

As you ponder different attitudes, check out these stick figures below. Take note of their uniquely shaped postures, their hand placement, and, of course, their faces and eyes.

Now let's practice the art of interpretation and bring these characters to life! Write a fun caption or message in each blank thought bubble below that you feel represents the stick figure's attitude and pose. Now, I'm sure you've copped an attitude at one time or another, so let's use your own words as inspiration here to give these characters a voice. What might they be saying? Who might they be speaking to? Give these stick figures a piece of your mind!

STICK
SKETCH SCHOOL
LESSON

Now that you've practiced giving voices to our stick figures, it's time to create your own characters! Sketch a series of stick figures in different poses, each one illustrating attitude through body language. Finish them up by adding messages or captions into a thought bubble above each character. Draw them into a situation where they might cop an attitude: maybe a character is rejecting someone who asked them out, or perhaps a stick soccer player is about to start the game and is staring down the other team. Let your attitude flow and bring your stick figure to life!

A FRACTION OF ATTRACTION
Creating Stick Figures That Draw You In

The art of attraction is a highly delicate dance. One wrong move can mean the difference between getting a phone number or getting a slap across the face! Subtlety is the true key here, because if you're attracted to someone, you want to let them know without scaring them away. A simple, well-timed batting of the eyes and a sly smirk or smile can be enough to send another stick figure head over heels with desire.

So are you ready to unlock the secrets of desire? Take a look at some of our flirty figures below. Pay special attention to things like sly eyes, shy smiles, subtle hand gestures, or even a stick figure playing with his or her hair! Notice how these elements really send out the "vibe" without saying a single word. Are you feeling it?

Now try to imagine what each stick figure is trying to say and fill in the blank thought bubbles below with your best pickup lines. Try some that are subtle and try some that are over the top! Feel free to let your friends and significant others join in the fun!

STICK
SKETCH SCHOOL
LESSON

Okay, now that you've practiced the love language of the pickup artist, it's time for you to create some flirty figures of your own. Using body language and poses like the examples opposite, create your own stick figures chilling at a night club, trying to pick up a few sexy stick figures that are dancing nearby. Focus on making welcoming facial expressions and poses that let the other stick figures know they're interested. Then, once you are finished, give your figures a voice by writing down some sweet pickup lines or captions.

TOUGH AND STICKED OFF
A Tough Look at Anger Management

Now that we've explored the language of attraction, let's head in the opposite direction and look at the language of repulsion. In this mad, mad world of stick figures, anger is a rich and valuable emotion that not only demonstrates dissatisfaction, but also serves as a warning for others: watch out or stay away! So how does this feeling manifest into artistic body language? First, create angry eyes with "V"-shaped eyebrows, and then add in a giant mouth full of gritted teeth for added anger. (And note, the bigger the mouth and teeth, the angrier the feel). But anger isn't only in the face, it extends to the limbs where we draw clenched fists with a simple rectangle in place of hands. And finally, there's no missing that aggressive stance that practically dares anyone to get in the way. We accomplish this by drawing the body or torso leaning forward.

Check out some of the angry characters below. Note the body posture and the facial expressions we mentioned above. What is it about these stick figures that tell you they are ticked off and looking for trouble? Let's pretend they are angry about something specific like getting a ticket, being rejected, or losing a game, and fill in the blank thought bubbles with an angry caption or message to match.

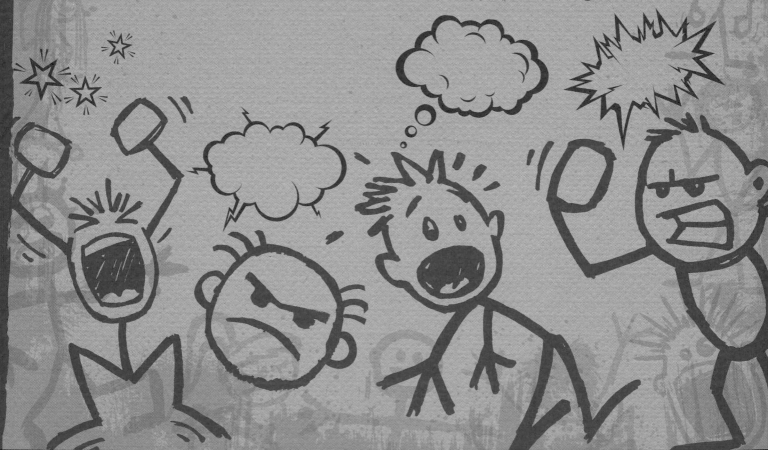

STICK
SKETCH SCHOOL
LESSON

Okay, now it's time to create some mad art! Let's practice drawing some angry stick figures. Make sure to experiment with accessories and backgrounds to illustrate why your stick figure is so ticked off. Pretend they are playing an intense game and are arguing a bad call by the ref. Or maybe they're arguing with someone about politics. Whatever you decide, make sure to give your character a voice by writing an appropriate caption or message in the thought bubble. And don't forget, you can emphasize the anger by adding a multitude of exclamation marks.

STICK SANITY
Driving Your Stick Figures Crazy

In this lesson, we're going to take a wild ride to the crazy side of Stick World and learn how to make your stick figures crazy. Stick figures, after all, can be insane, hyper, or just plain odd. Perhaps they've got a vicious coffee addiction and are in dire need of their next cup, or maybe they are frustrated and crazed parents with rowdy kids! Whatever the cause for their hysteria, there are a lot of details to be found and used when trying to capture the crazy!

So how can you tell if a stick figure is crazy? Good question! Our stick figures express their crazy body language with flailing arms and legs that can be drawn bending and pointing in several different directions. Once the limbs are done, move up to the face by drawing oversized, unpredictable eyes, rolling googly eyes, or even bug eyes that seem to be looking in two different directions. Add in a wavy-lined smile and top off the crazy body language by drawing some wildly scribbled hair that looks as if the stick figure stuck his finger in a socket! Now they've gone totally bonkers!

Let's take a look at some of our crazy stick subjects below in various stages of mental instability. What is it about these characters that speaks the language of crazy? Do you see the crossed eyes and flailing limbs? Try to identify as many "crazy" elements as you can, and then imagine what exactly has driven these poor souls out of their right minds. Determine what or who caused their insanity, and then give them a voice to tell us about it by writing a caption or message in a thought bubble.

STICK
SKETCH SCHOOL
LESSON

Let's go crazy! Using the techniques we've discussed, create your own sticksane asylum of wild characters. Perhaps one of them survived a recent zombie apocalypse and is bandaged up from the experience. Maybe another has gone mad from trying to solve a Rubik's cube. Whatever craziness you decide to inject, once you've created the character, finish them off with a fun caption that really tells their story. Try to make it short and sweet; you know, as if they are muttering the same words over and over!

STYLIN' & PROFILIN'
Hints to Creating a Little Confidence and Swagger

You can't always explain it, but when someone is confident, you just know it. Many times you can see it in the way they present themselves. We call it swagger, and as we try to infuse our stick figures with some swagger power, it helps to try and imagine what makes them so confident. Knowing why will help you draw it!

No matter the source of confidence, it is key to show off that source as much as possible by featuring it prominently in your art. For example, if a stick figure has confidence in his or her looks, then show her brushing her hair or posing in flattering positions that best show off her attributes. If a character is confident in his or her physical abilities, like an athlete or superhero, perhaps you can illustrate him flexing his muscles or standing in a physically intimidating pose. And finally, if a stick figure gets his confidence from a material possession, then you definitely need to sketch them posing in a way that shows off the object as much as possible. Like a stick chick flashing a diamond ring, her hand waving dramatically in the air. Or a stick dude leaning up against his flashy new car or hiding behind a sweet pair of shades.

Check out the stick figures below and see if you can identify their source of confidence. Now, give them a voice by writing a cocky caption into the empty thought bubbles. Have fun with the dialogue and see if you can portray the difference between a little confidence and downright arrogance!

STICK
SKETCH SCHOOL
LESSON

Now that you've given our stick figures some encouraging words of confidence, it's time for you to create your own! Imagine a setting where your stick figures might be looking to show off. Could be soccer players mad-dogging their opponents. Maybe it's a group of stick figures chilling on the boulevard with their souped-up cars. Or perhaps it's a group of stick supermodels in a posing contest as they fight for camera time. Whatever crazy concept you come up with, create some cool characters striking poses and showing off their swagger. Dress them up with some accessories, like shades, headphones, stilettos, or whatever you think might provide that "it" factor. Then, give your characters a voice and share their thoughts with a caption or message in a thought bubble.

SICK AND TIRED
A Depressing Look at Sick Sticks

Our last lesson will take us on a downer of a trip through our stick figure infirmary as we visit with some of our sick and sad stick figures and learn the body language of a few "Debbie Downers."

Just as a stick doctor might do, let's gauge the level of illness or sadness in our patients by studying their posture. A sickly or sad stick figure would have a curved body that sags forward with limbs that hang down to the floor—of course, that's if they are even able to stand up. Now if it's a more serious condition and your stick isn't going to make it, then your stick figure would likely lie in the classic dead and sprawling pose, or what many call the "X" pose with all limbs pointing straight and outward like the letter X. Of course, this is finished off with literal X's in place of the eyes. Stick shortcut note: One X'd eye means only *mostly* dead, while two X's mean all dead. And if you want to really emphasize your stick corpse, feel free to add a hanging tongue or broken stick limbs lying all around.

Lastly, as these figures mope around looking for your sympathy, many of them will display visible accessories that really give away their conditions, like a bandage, a cast, a thermometer hanging out of the mouth, a water bottle on the head, or even heat waves, stars, or birds flying around their heads.

Think you got it? Then it's time to get illin'! Take a look at our examples of sick and sad below. What indicators tell you how these stick figures are feeling? Who do you think is feeling the worst and why? Now write a creative caption or message in a thought bubble for each character based on what you think they are thinking or saying. It could be simple phrases like "Ouch!" or "Ugh!" Or you could dig a little deeper and give some hints to their stories like, "Did anyone catch the license of that car?"

STICK
SKETCH SCHOOL
LESSON

Are you sick of this lesson yet? Using what you've learned thus far, create your own sick and sad stick figures at your local stick hospital or at the scene of an accident. Try to increase their level of pain and affliction from a slight "ouch" to a near death experience. Then give each character a creative caption or message in a thought bubble that best states what happened to them!

CHAPTER 4

STICK EMOTIONS

A Moody Look at the Highs and Lows of Stick Living

Stick figures are emotional creatures that can literally wear their hearts on their sleeves. Just like you, they can feel a range of emotions—from happy and sad to scared and excited. Whatever emotion or mood they may feel or be in at a given moment, you should be able to take a quick look and know what they are thinking or feeling. In this chapter, we will review a range of emotional examples to try and help you project those feelings artistically. After completing this chapter, you should have the skills to bring emotional stability to your stick world! Are you ready? Let's get emotional!

COME ON GET HAPPY
Expressing Your
Happy Happy Joy Joy

Happiness and joy are essential to living a good life, and stick figures are great at spreading that joy to the rest of the world with their fun expressions and joyful body language. Whether it's learning to ride a bike for the first time or celebrating a birthday, when something good happens, stick figures can't keep it to themselves—they have to tell it to the world! So, in this lesson, we'll take a good look at several happy expressions, and then you can practice emulating that joy with several characters of your own.

Take a look at these happy examples below. First, look at the face: notice how the size of the smiles can express just how happy they are. Next, look at the eyes: can you see the joy welling up in them and how simply that can be accomplished with a pen or pencil? And finally, examine at the body language; what do the actions and angles of the body say to you?

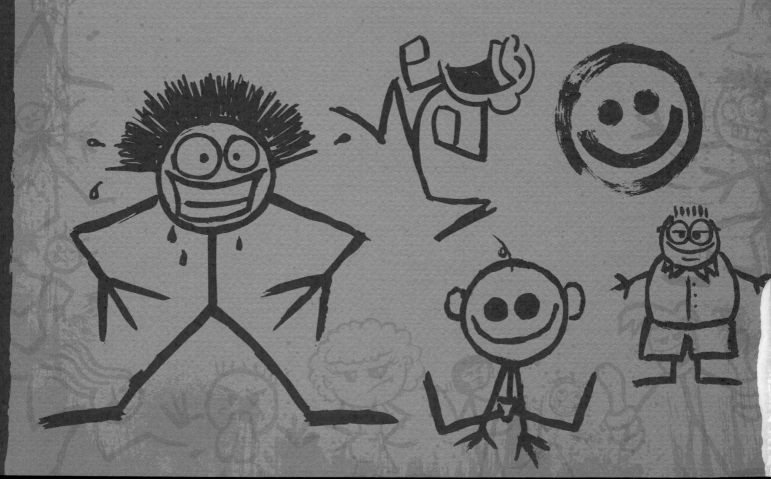

STICK
SKETCH SCHOOL
LESSON

Hum a tune, tap your feet, or tickle yourself with a feather because it's time to get happy! Now it's your turn to draw some stick figures in various states of happiness, from genuinely pleased to overwhelmingly excited. Practice enlarging the size of the eyes and mouth to increase the levels of joy and happiness. Use body poses like pumped fists and raised hands to really put the emotion over the top.

ANGER IS ALL THE RAGE
Being Angry Is Nothing to Get Mad About

What ticks you off? Whether it's the result of your favorite team losing the big game, stubbing your pinky toe, or getting cut off in traffic, anger is a normal emotion that finds us all at one time or another. After all, there's a lot of stuff to get angry about in life. And because there's so much stuff to get angry about, sometimes we need to get creative in finding new ways to blow off steam. Well, say no more! Here's your opportunity to get out a little rage! Our stick figure friends are ready and willing to feel your wrath and absorb your pain in order to help you come to grips with expressing your anger in art.

Take a look at some of our angry stick figures below. Do you see the clenched teeth, the furrowed eyebrows, the little black smoke wisp coming off the top of the head? The clenched fists and forward-leaning body are strong body language indicators for anger. It's almost as if the stick figure is storming right off the page or ready to confront someone or something. What other details or embellishments do you think would add to the visual clues of an angry-feeling stick figure? A hole punched through a wall, a broken window, a crushed can? In this case, the setting is helping you express anger. Although, perhaps it's best if you avoid those things lest you get accused of having anger management issues yourself! Want to know another furious fact? Rough, scribbled lines are a subtle detail that can add to the chaotic feeling of anger in your stick art.

STICK
SKETCH SCHOOL
LESSON

Okay, are you ready to get mad? First, you need to find some inspiration to create your angry stick figures. Is it the bully who taunted you in school? Is it the traffic cop who just gave you a parking ticket? Or perhaps it's just your phone or computer that decided to stop working when you were desperately waiting for an important message! Wherever you pull your inspiration, try re-creating an angry moment using the techniques in this lesson. Practice different levels of anger, from slightly miffed to totally ballistic. Whether it's larger eyes, a bigger mouth, or a higher degree of angle in your furrowed eyebrows, pay special attention to the use of size and how it can help escalate the look of anger in your stick figure.

HOW TO MAKE A STICK FIGURE CRY
Pass the Prozac, Please

In life, there is a lot of heartbreak and hurt—painful moments that can rip a little stick heart right out. But fear not! Everything's going to be okay, because you have your stick friends to help you get through the tough times. Yes, right now, stick figures are standing by ready to hear all about the heartache and suffering, and they want to help. So what does that look like? Glad you asked.

Take a look at the mournful stick figures below. Poor souls. What visual clues tell you that these stick figures are sad, depressed, or despondent? Sure, there are the obvious tears, but do you see the eyebrows that are drawn in the opposite angle of the anger eyebrows? Did you notice the sunken shoulders of defeat? Sagging limbs, a drooping posture, and a lowered head are great techniques to use if you really want to send your stick figures into a full depression. What other physical indications could we add to really put these stick figures into a full downward spiral?

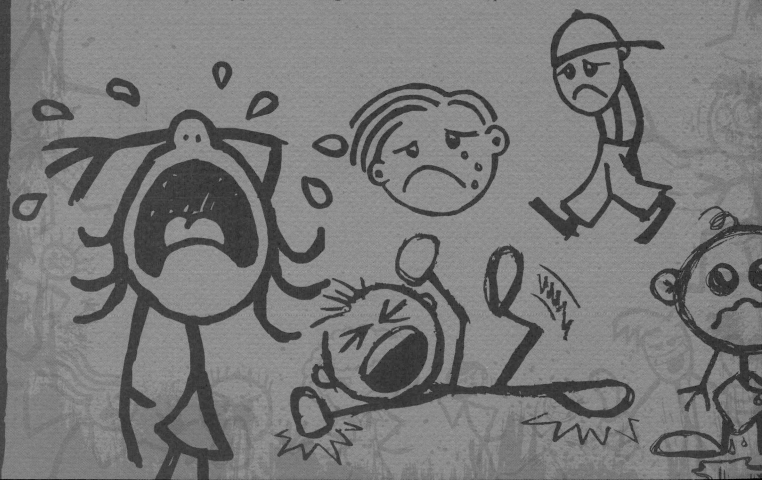

STICK
SKETCH SCHOOL
LESSON

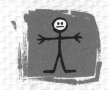

Put on a tear-jerker movie and pick up a pint of ice cream, because it's time to practice the art of wallowing. Practice drawing some stick figures in various levels of sadness, ranging from disappointed to despondent. Pay attention to the visual clues that create a deeper level of despair for your stick figure. Try adding accessories, like tears or even a thought bubble to indicate why they are sad.

LOVE STRUCK
Draw Your Stick Heart Out

Ah, love. Such a beautiful thing. So many things have been done in the name of love—stupid, crazy, desperate things, as a matter of fact. Like any other emotion, love can be experienced on a variety of levels, ranging from early infatuation to deep passion. Some who may claim to be "in love" really fall more under the category of borderline-stalking. In this lesson, we'll explore the many faces of "love" and try to connect our stick figures as they fall head over heels.

Now, when the love bug bites a stick figure, it can start with something as simple as an interested glance that manifests itself with puppy dog eyes and a dreamy smile—innocent enough, right? But at other times, stick figures feel the love so deeply, their little stick hearts pound right out of their little stick chests—literally! Floating hearts can indicate that these poor fools have been transformed into desperate, love-starved maniacs! These love-crazed stick figures can be identified by their klutzy behavior, such as tripping over their own feet when that special someone walks by, as well as their large, wide eyes and unpredictable smiles. You know those crazy smiles; the ones that make you wonder whether or not it's safe for you to *stick* around! Take a look at some of the examples below.

STICK
SKETCH SCHOOL
LESSON

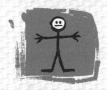

Are you ready to fall in love…with your stick figure? Using our examples of love for inspiration, create your own lovesick stick figures. Their love can range from puppy love to obsession, which may run the risk of a restraining order. Pay attention to the accessories, like floating hearts, and visual clues, like huge eyes and maybe even a heart beating out of the chest to increase that level of passion.

CRAZY IS AS CRAZY DOES
You Can't Fix Crazy,
but You Can Draw It

Welcome to the stick world asylum! As we enter this padded room lesson, remember we are only speaking about the mental health of our stick figures. And it's important to note that these crazy stick people do not "suffer" from any condition; rather, they relish and thrive in their freedom of expression! They embrace their unpredictable traits and wrestle with their invisible friends while hugging themselves tightly in a straitjacket. Stick figures need to express their instability, and in this lesson we will teach you how to help them do that visually.

Take a look at our stick figures in the examples below. What visual clues show their craziness? Notice the large eyes and smaller pupils. Does it seem like they are looking off into another land? How about the nervous stick figure with the shaking action lines around his arms and legs? Is he over-caffeinated or just plain crazy? Devious smiles or hand-wringing can also indicate degrees of instability if drawn effectively. If you want to draw a stick figure that is criminally insane, are there elements or accessories help tell that story?

STICK
SKETCH SCHOOL
LESSON

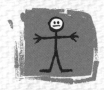

Okay, it's time to get crazy! Try making use of the elements and visual clues you've learned in this chapter (or from real experiences!) and create your own crazy stick figures, ranging from a little hyper to a straitjacket-wearing Hannibal Lecter. Add some different details like thrashed hair or two eyes looking in opposite directions. And include some accessories like oversized or undersized clothes. Sometimes the smallest details can really elevate the level of insanity in your stick figure.

BE AFRAID, BE VERY AFRAID

Creating Shock and Awe in Your Stick Figures

There are no less than 530 documented types of phobias in the world. So, as we explore new and exciting ways to scare our stick figures, we certainly have a lot of places to look for inspiration. There is the unexpected discovery of a hairy spider in the tub that can trigger arachnophobia. There's the fear that causes some to faint at the mere sight of clowns—coulrophobia; while others simply have trouble speaking in front of crowds—glossophobia. In this lesson, we'll practice coping with our fears using one of our favorite methods: scaring others! Yes, it's amazing how watching someone else scared out of their wits can help us forget that we were ever afraid ourselves! So let's dive right in and check out these frightened stick figures.

Take a look at the cowardly exhibit below. What visual clues do you notice about these stick figures that express the level of fear and paranoia they are experiencing? Is it the deathly screams coming from their gigantic mouths? Perhaps it is the beads of sweat coming off their heads, or the trembling or shaking of their bodies? Or even their hair standing straight up and their eyes fixed as wide as a dish plate? Perhaps it's all of the above!

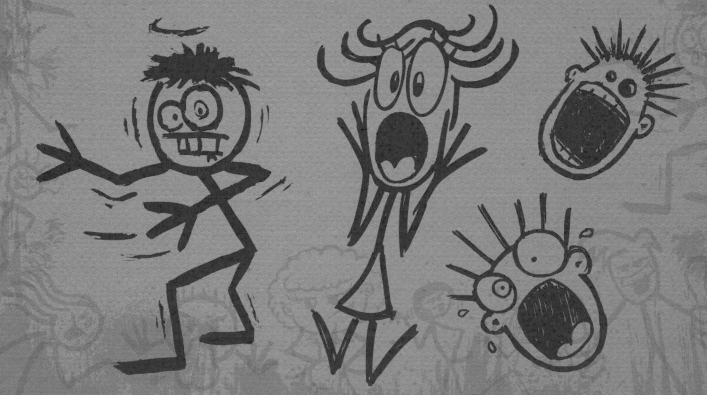

STICK
SKETCH SCHOOL
LESSON

All right, it's your turn to scare up some frightened stick figures! Now that you care how you scare, create your own fearful friends, ranging from "slightly paranoid" to "I just wet my pants!" Consider adding details, like motion lines to indicate shaking, or a wide open mouth and hair sticking straight up to demonstrate shock—anything to tell the story of why your stick figure just can't cope.

GROWING UP STICK

The Obvious Signs of Stick Aging

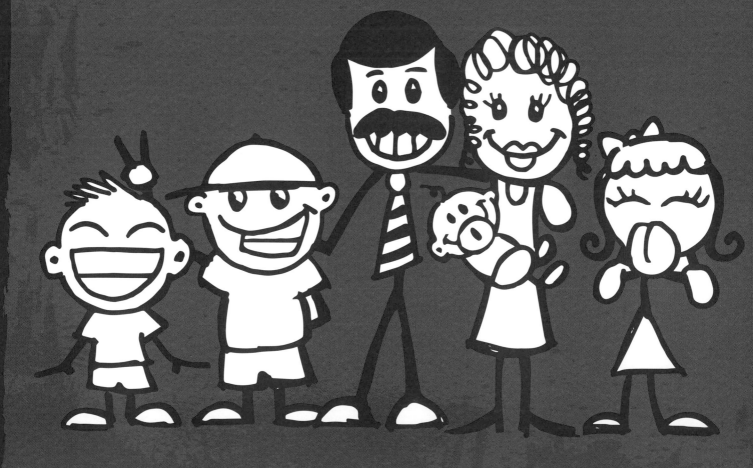

Who says getting old is no fun? In this chapter, we will examine the stick figure's life span, from the cradle to the grave. You will learn details and elements that you can easily use to portray different ages and life stages of your stick people. Yes, even stick figures get old! And as they do, they take on very similar characteristics that you or I would, including longer limbs, different hairstyles, and wrinkles, of course. As we explore different methods for expressing the ages of our characters, you'll have the chance to create your own stick babies, stick kids, and even stick grandmas and grandpas while practicing your artistic aging techniques.

Okay, are you ready to grow up? Let's get started!

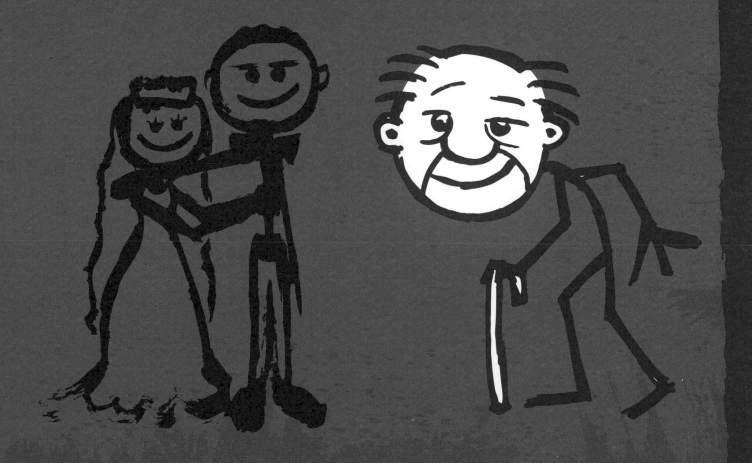

MAKING BABIES
Lessons Your Parents May Not Have Taught You

Babies are easy to make—stick babies, that is. These little bundles of joy can really increase the cute factor of any stick family with their sweet, little innocent faces and natural baby charm. And best of all, stick babies are much easier to care for than human babies. Heck, even clothing is optional for babies in Stick World!

Now, just like with real parenting, you'll have to make some of the same tough parental choices facing normal human parents. For example: Binky or no binky? Bottle or no bottle? And you'll want to explore methods for showcasing your baby's gender while you wait for their hair to grow in. After all, you don't want people misidentifying your stick baby in public, do you? Gasp!

Now, let's take a look at some of our infant babies in the stick nursery. Right away you can see the shorter limbs and smaller torso combined with the larger head. This body-to-head ratio is usually a great place to start when making babies. But also take note of the simple use of a triangle-shaped diaper. It's much easier to draw one of these than to try and put on a real one, huh? And feel free to add a safety pin for a retro look. Next, key in on some of the obvious accessories that give visual cues to help determine the gender, like a bow in the hair, eyelashes, clothing, or a toy. What other elements can you think of to distinguish your stick baby?

STICK
SKETCH SCHOOL
LESSON

Are you ready to become a stick parent? Let's make some babies! Practice creating your own stick babies using some of the techniques you've just learned. Imagine you are the new stick baby in the stick nursery. What other babies are there with you? What's the pecking order? Who is the leader of the stick babies? Is it you or are you the big bully baby? Are these babies led by a charismatic stick infant leader who can get them all to drink their formula? Will you drink it, too?

STICK KIDS:
IT'S ALL ELEMENTARY
Drawing on Your Parental Instincts

Physically, as your stick kids begin to grow up, they experience some very noticeable changes. You'll see more hair than on the babies, more teeth in their mouths, and, of course, more clothing and accessories. In addition, the size of their heads and bodies will become more in line with one another, but you should still use shortened arms and legs. These little tykes grow so fast that it's tough for a parent to keep up! So, just like with real parenting, it's best to try and outfit your stick child with clothing that is a few sizes larger than necessary. It makes for a cute look and helps you avoid having to buy new clothing every other week. That gets expensive!

Emotionally, stick kids really start to blossom as they grow. They become overly expressive and are more action-oriented than babies as they play, play, play. And as you illustrate those actions, make sure to use lots of motion lines to highlight the movements. Laughter and silliness are also abundant—so big smiles, innocent wide eyes, and even crazy eyes should be the standard on your drawings.

Adding accessories like toys is also important when drawing stick kids. They do love to be spoiled. Notice the use of facial features like freckles and teeth, or missing teeth in some cases; all of these help to shape their youthful facial appearance. Hair helps to illustrate not only age but also gender, like pigtails for girls. One of the best tricks of the trade though is oversized clothing. Nothing screams kid like a few ill-fitting hand-me-downs!

STICK
SKETCH SCHOOL
LESSON

The recess bell has rung, so it's time to play! Now it's time for you to be the parent and create your own stick children. Draw them on a lively stick playground. Are they playing kickball? Or freeze tag? Maybe they are playing on the swings or the slide. Use the techniques you learned in this chapter to make the scene come to life.

SMELLS LIKE TEEN SPIRIT
Finding Your Stick Teen's Identity

As your stick kids become stick teens, you begin to notice some serious changes. In addition to growing taller and having longer limbs, hormones begin to rage, acne appears, and hair begins to grow in all the wrong places. And as difficult as it can be to predict the behaviors of individual stick teens, one behavior that is fairly consistent is their need to "find themselves."

Most stick teens begin searching for their identity either through movies, music, fashion, friends, activities, or sports. What does that mean for stick teens? This dramatic time in the adolescent identity crisis can manifest itself in outrageous hairstyles, clothing, and accessories, like jewelry, piercings, and yes, even stick-style tattoos.

Let's check out some stick teens in their natural environment below. Yes, these teens are drawn taller than kids in the previous chapter and their limbs are now longer and more proportioned to their bodies. Do you notice the unique hairstyles, clothing, shoes, and "accessories" they use to tell the world who they are? Dressing up your sticks teens with funky hair, clothes, and accessories will be the key to making your stick figures stand out from the crowd. So go big on those glasses when creating a stick geek! Make that Mohawk stand tall when creating that rebellious teen! And make sure to show stylish elements like skinny jeans, pegged pants, cool caps, and all the latest trendy clothes when drawing those hipsters and fashionistas! And don't forget accessories like skateboards, headphones, backpacks, books, or other favorite teen trinkets.

STICK
SKETCH SCHOOL
LESSON

Okay, now it's your turn to try and connect with your teenagers. Create your own stick teens chilling out together in detention. Create a jock, an emo, a fashionista, a rebel, and a geek. Draw some figures sitting at their desks while others are just standing around looking cool. Again, focus on accessories to set them apart. But also consider how they might feel about one another and how they might interact.

GROWING UP
Coming of Age in Stick World

Welcome to adulthood! Now you'll have to start paying rent and bills and taking responsibility for yourself. That means you'll likely have to ditch that Mohawk and those body piercings if you want to get a "real" job and make it in the "real" world. Unless, of course, you plan to make it as a rock star! Good luck with that!

As reality sets in, the tough life lessons take their effect on the stick adults, and you begin to see changes in their physical appearances, like facial hair on men. The stick adult's fashion sense suddenly takes on a more professional appearance, too, particularly if the stick adult has found their identity through a career or hobby. Yes, the stick adult has finally found their place in life.

Don't worry, though, stick adulthood doesn't have to be all about work, work, work. While some will indeed choose a career path, others will also go the family route and become moms and dads. Mom stick figures will reveal themselves with baby bumps, coffee mugs, bunny slippers, and swagger wagons (that's "minivans" for the layman), while daddy stick figures will showcase their unshaven faces and potbellies as they experience the joys of hair loss. Of course, these are only a few faces of stick adulthood. Can you think of some more?

Check out these adults below. What makes them appear older? Can you see the career paths they've chosen? Keep in mind, the presence of kids in any scene should help define who the parents are and who the kids are visually and with great ease!

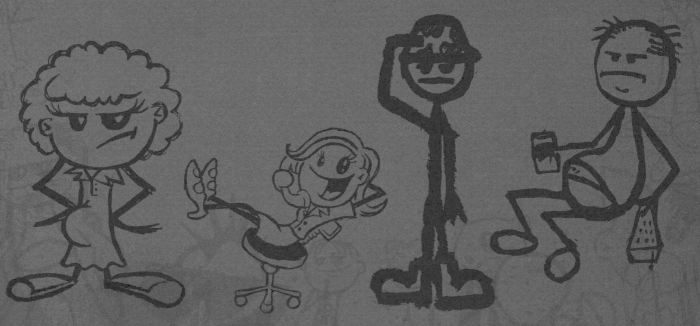

STICK
SKETCH SCHOOL
LESSON

Now it's time to grow up! Create your own stick adults hanging out at a family BBQ or at a piñata-bashing birthday party. Make sure to include children to make the adults more obvious.

TOO OLD TO CARE
The Obvious Signs of Aging

Physically, aging can be cruel to us all, including to the stick figure. But stick figures embrace their golden years with the same zest and enthusiasm of their youth. So, bring on the hair loss! And liven up those wrinkles! It's time to get old!

As the aging process kicks in, the stick figure begins to slow down…way down. Their body language should display a slower pace as the body begins to droop. This is easily accomplished by taking the straight-lined vertical stick body and curving it forward. Of course, you can always add a cane or walker for emphasis. Weight loss also kicks in, and that usually means a sudden need to pull the pants up above the stomach. So, the older stick person will typically feature a much higher waistline, with long hanging arms for emphasis. Of course, hair loss continues among older stick men, while more traditional hairstyles and fashion become prevalent on the older stick women. But most importantly, they say that wrinkles are the tattoos of wisdom, and as the stick figure transitions to the golden years, they carry with them all the experiences of life written right there on their faces with laugh lines, wrinkles, and maybe even lost teeth. Laugh lines are those lines that run from the nose to each side of the mouth. Combine those with some semi-circles under the eyes, and you'll dramatically increase the age of any stick character. Throw in a few blacked out spots to simulate missing teeth, and you're in business! And that's not the only thing they carry. Aging stick figures also carry a plethora of accessories that are unique to their age group, like glasses, medications, canes, walkers, wheelchairs, and even metal detectors.

Now, check out these aging stick figures below. Can you see the obvious signs of aging? Can you think of some details or accessories that might help age them even more?

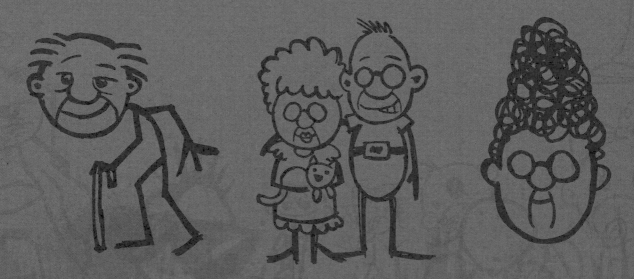

STICK
SKETCH SCHOOL
LESSON

Now it's your turn to re-create some classics as you use some of the ideas and elements in this lesson. Try sketching your own grandma or grandpa with their everyday accessories, be it a fanny pack or a floral shirt. For a real challenge, try portraying yourself in 50-plus years from now. Whomever you portray, try creating several different characters using different elements to age them. See how old you can go!

THE STICK FAMILY PORTRAIT
Welcome to the Family!

Okay, so we've covered the entire life span of the stick figure from babies to retirement. We've learned how different elements can help portray a specific age. All that's left now is for you to make a stick family portrait of your own family!

Check out our stick family portrait below. Notice the different ages of each character? What elements help determine their age? What other elements could we have used to enhance their ages even more?

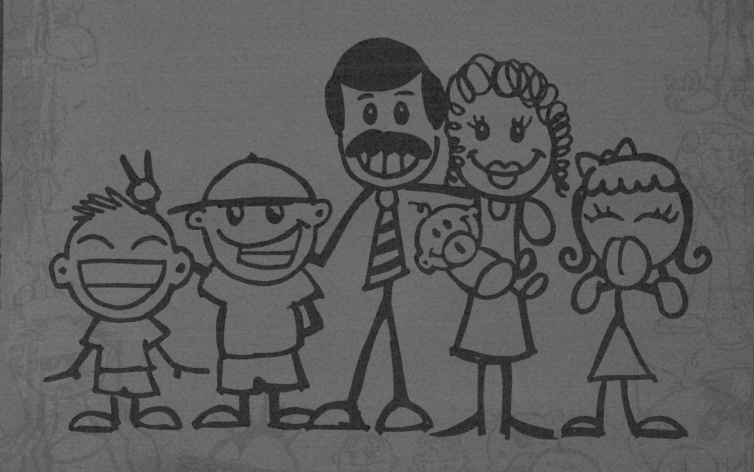

STICK
SKETCH SCHOOL
LESSON

Now it's time to put all the lessons from this chapter about stick figure aging to use to create your own stick family portrait! Using your own extended family as models, try illustrating some of your family members into one large family portrait. What distinctive elements do each of your family members possess that can be portrayed artistically? Try starting with your immediate family and then branching out from there. Include the crazy aunt on your dad's side and the weird cousin that never speaks. Don't forget the uncle who only speaks through his ventriloquist dummy, Jeremy. Who knows, when you're done you may just end up with the perfect picture for next year's Christmas card!

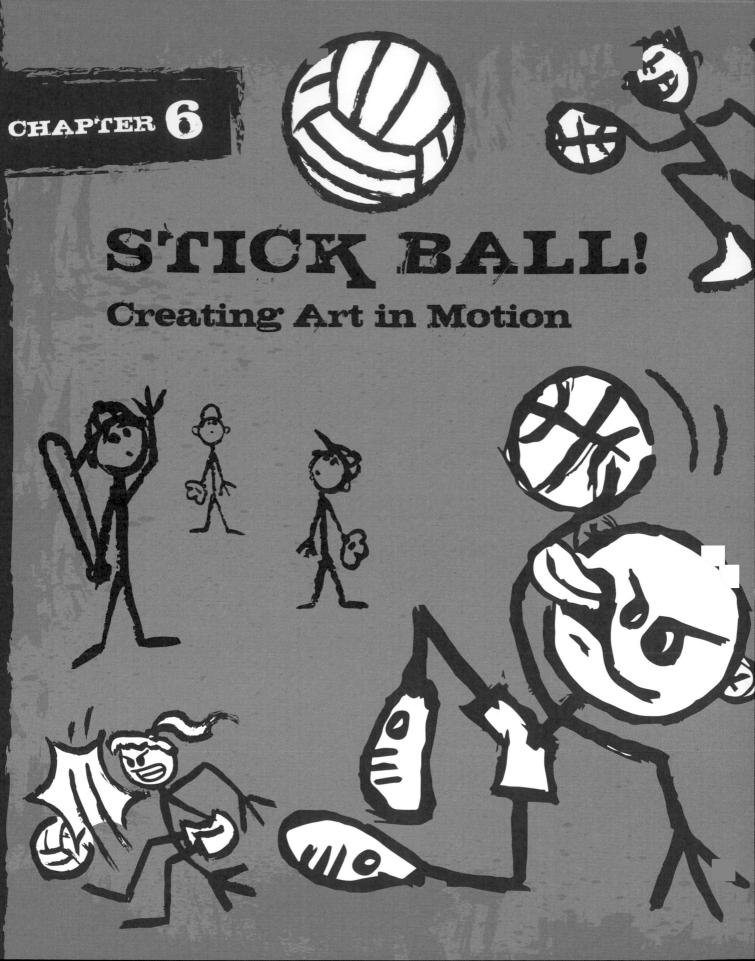

STICK BALL!

Creating Art in Motion

Art and sports have been historical teammates since the days of the first Olympics in Greece. The athletes and events of the Olympics were frequently captured in magnificent glory by storied Greek artists, sculptors, and even poets whose works are still sources of artistic inspiration. So what better way for us to be inspired in our stick design than to look to the art of today's most popular sporting events, where the action is so fast and furious that it will inspire you to create artistic works as glorious as that of any historic Greek artisan!

Of course, before we show our stick motion art to the world, let's try practicing a few designs on our own. In this chapter, we'll apply what we've learned already about different body types and focus on adding action and movement to them. Though there are dozens to choose from, let's explore six of today's most popular sports. From the tall and lanky hoopsters to the buff and beefy footballers, we'll take to the field with baseball, soccer, basketball, football, and more, as we create teams of stick players in action. So let's suit up, stretch, and take the field because it's time to play stick ball!

FOOTBALL
Tackling the Art of the Gridiron

To some, football is just a game; to others, it is a way of life. Regardless of whether or not you're a fan, most would agree that football is tough. With bone-jarring hits and relentless passion and fury on display, athletes are pushed to their limit. In this lesson, we'll explore the unique artistic expression found in the game of football.

Let's tackle the art examples below and try to identify what unique elements are helpful in drawing football scenes for your stick figures. Compare the different stick ballers and notice how the use of blocky and oval-shaped bodies helps to create buff and beefier-looking characters. Need a quick shortcut for illustrating movement? Use slanted limbs! If you look at the art below, you can see how easily slanted arms and legs can illustrate action and motion. Also, a few lines placed in the right spots can reinforce the idea of motion or action, such as the ones coming off the back of a stick figure to give the visual clue that the character is running fast.

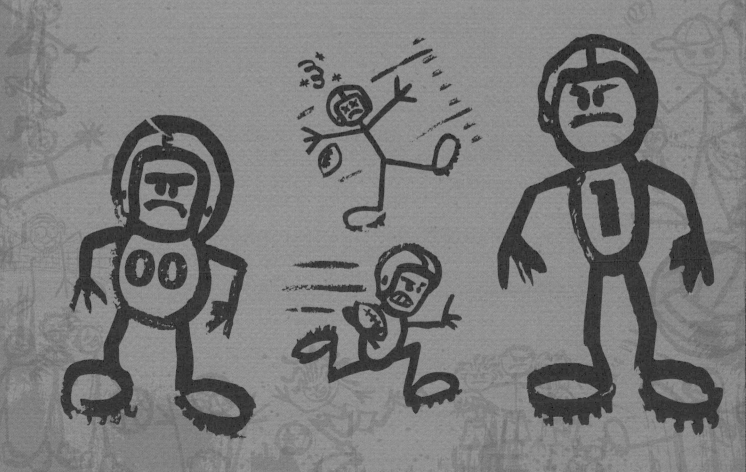

STICK
SKETCH SCHOOL
LESSON

Now, try to create your own football star. Perhaps he's leaping up to catch the winning touchdown pass with only seconds left. Be sure to use a wide oval-shaped body to create the beefy body effect. Remember, your players are going to need the right equipment if they're going to reach the goal line and score a touchdown! So don't forget important details like helmets, cleats, and even random action lines to show movement.

BASEBALL
Swinging for the Line Drive

Take me out to the ball game and buy me some hot dogs at the seventh-inning stretch on a warm summer night! Yes, for baseball fans there is no better sound in the world than the crack of a bat as a player sends a ball hissing into the stands. Big fans will always remember the first time they saw one of the greats take the field, like Babe Ruth, Joe DiMaggio, or Ted Williams. Let's use some of those great memories as inspiration to capture a little baseball action with our stick art. But if you can't remember back that far, try checking out some current baseball pictures from today's big leaguers to give you an idea of what some classic baseball poses might look like. Try to emulate those images while making sure to dress up your stick figures with lots of action lines that will really bring the players to life.

Are you ready for the change-up? Take a look at the baseball players below. Do you see any noticeable differences in their shape and styling from the football players in the previous lesson? There are the obvious differences in gear: baseball players have hats, bats, and gloves instead of football helmets and pads. Also, physically, baseball players aren't traditionally as round and large as football players. So instead of rounded bodies, you should draw more slender torsos. Now let's pine tar up that bat and step out of the on-deck circle; it's time to take a swing at creating some stick ball players of your own!

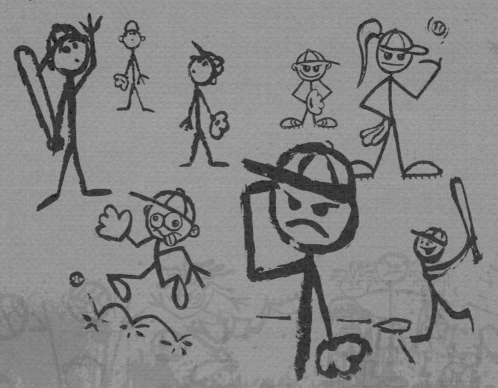

STICK
SKETCH SCHOOL
LESSON

Now it's time to re-create your own baseball action sequence. Try drawing your favorite players swinging for the fence or diving to grab a line drive. Pay close attention to body shape, uniform, and equipment while adding plenty of action lines and poses to give your player a look that's sure to be a hit!

BASKETBALL
The Art of Trash Talking

Hoops ain't for everyone. You've either got game or you go home! And here, taking someone "to the house" takes on a whole new meaning as buzzer-beating three-pointers make champions out of underdogs, and athletic giants remind us that height is king, unless you've got the vert to match. You followin' along? As we try to capture that on-the-court magic with our stick art, let's ponder some of the popular words and phrases that you might hear in and around a trash-talking blacktop. Use those as inspiration for the poses and scenes. Keep it clean! We don't want any fouls! And when you're creating stick figure basketball players, keep in mind that ballers aren't just tall, they can come in many shapes and sizes. Mixing them up can make for some hilarious combinations. Ready to jump in? All right, GAME ON!

STICK
SKETCH SCHOOL
LESSON

Now that you're inspired, let's re-create some of that "on-the-court" action with your own set of plays! Using some basketball terminology of your own, create some stick ballers going at it in a game of one-on-one or three-on-three. As you create the players, add some fun words or sayings to go along with their poses; it could be some trash talk or just fun descriptions like "Rejected" or "Big Air!"

SOCCER
Get Your Head in the Game

Soccer. Okay, yes, so the rest of the world knows it as football, or fútbol, but whatever you decide to call it, there's no denying its popularity, as evidenced by the millions of obsessed fans that paint themselves and pack into sold-out arenas around the world. It's that same passion that we hope to capture as we draw some stick soccer art. Now, understand, drawing a red card is very different from drawing a picture, and even though you're not allowed to use your hands in the real game, we're going to go ahead and make an exception for you with this lesson, unless, of course, you're feeling adventurous.

Okay, it's time for us to hit the field. Let's check out some of the unique art from the world of soccer! In this lesson, we are going to build on what we've already learned about body shapes by paying particular attention to the action lines and the heads of our players. Yes, the heads! Soccer players have some of the most amazing hairstyles of any sport out there (wrestling excluded, of course!). As you examine the stick players below, focus on the great poses that are unique to the sport of soccer, while enjoying the unique hairstyles that really set them apart. Do they remind you of any specific players or teams? Does your favorite player have a unique hairstyle or feature that you can emulate in your art?

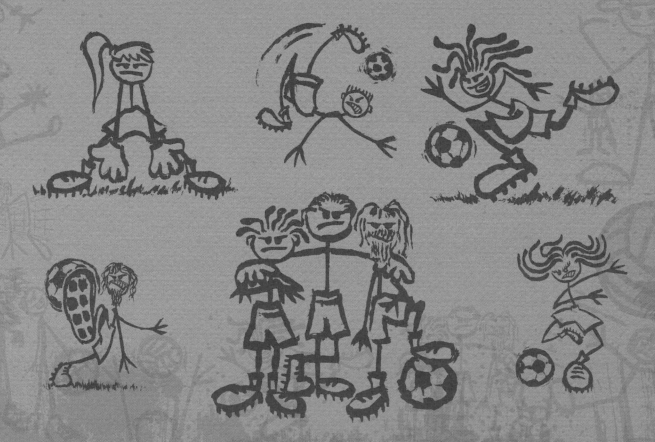

STICK
SKETCH SCHOOL
LESSON

Now it's time for you to take the field and draw your own team of stick soccer players. As you begin, try to use your head by utilizing some of your previous lessons or real-life experiences. Start by using some of the classic terms you may have heard on the soccer field or shouted from the TV sportscaster like, "GOAAAAAAAAALLLLLL!" Remember to pay special attention to the use of those action lines to emphasize speed and movement since soccer is an extremely active sport! And don't forget to finish them off with some of those patented soccer hairstyles! Ready? ¡Vámonos!

HOCKEY
Art on the Ice

Hockey fans are a unique bunch. While the sport may not have the popularity of other sports in America, hockey lovers are so fanatical about their game that what they lack in numbers they make up for in craziness. The game itself combines the violence of football and the speed of soccer with the unpredictable nature of an MMA match. Ah yes, there's nothing better than a nice hard "check" to the gut to get the blood flowing, for both fans and players alike! Whether it results in missing teeth, black eyes, or cracked ribs, finding glory on the ice can sometimes be a real challenge. And the same goes for depicting that ice on paper!

Hockey players may not be huge, but once you pack on their five hundred pounds of pads and gear, they begin to beef up in a big way, so keep that in mind as you decide on shapes and sizes for your characters. When it comes to details, make sure your stick players are geared up with the distinctive tools of the trade, like hockey sticks, skates, and goalie pads. And, of course, you can't forget to dress up your team with accessories. In hockey, that could include all of those distinctive wounds and injuries, like black circles around the eyes, missing teeth, and X's in place of eyes to show that they've been knocked out cold! These inflictions are like badges of honor and are a source of great pride among the goon squad!

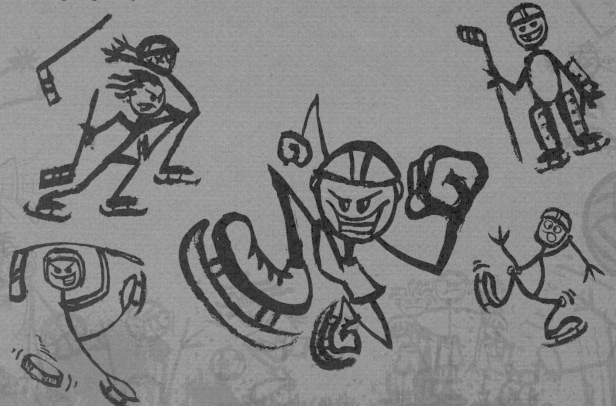

STICK
SKETCH SCHOOL
LESSON

Okay, get out of the penalty box, because it's time to power-play and create your own stick hockey team! Create a stick hockey brawl of your own devices. A player has just high-sticked a rival from the other team, costing them the goal. The players are mad, the fans are ticked, and it's an all-out war on the ice!

THE CORNUCOPIA OF THE WORLD OF SPORTS

A Tribute to the Games You Still Hunger For

All right, team! We've rounded the corner, and we're now in the homestretch! Now that you've got some basic stick sports experience, it's time to practice illustrating some of your favorite sports. So what sports are you into? Perhaps you're a bit of a loner and prefer solitary sports, like golf, tennis, or even boxing and MMA. Or maybe you're addicted to the adrenaline rush of extreme sports, like skateboarding, snowboarding, and BMX! From beach sports, like surfing and volleyball, to mountain adventures, like skiing and snowboarding, there is a cornucopia of different sports that we couldn't possibly cover in just one book. So it's time for you to get geared up and put your game face on for your fave sports!

Okay, let's remember, we're not in the real world; we're in the stick world. As you consider the sports you want to draw, check out some of the examples below and feel free to go out of bounds for this sketch and explore the space! No really, explore the space! Consider some of your family, friends, and loved ones, and think about how ridiculous they might look playing sports that are totally unlike anything they'd play in real life. Like Mom playing tackle football, Dad doing gymnastics, or your significant other hang-gliding! Can you imagine the possibilities? Have some fun with it!

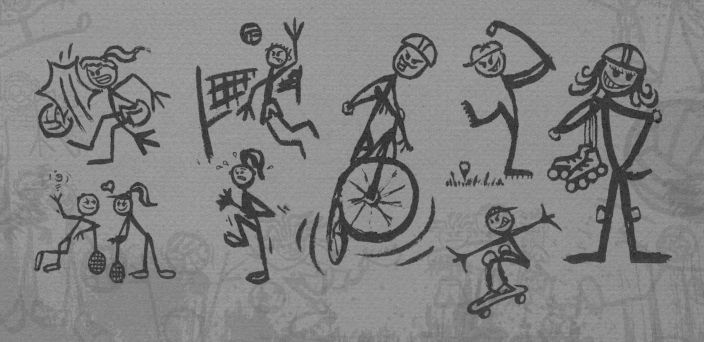

STICK
SKETCH SCHOOL
LESSON

Are you ready? Mix and match your favorite people with their favorite sports. Or if you're up for a laugh, perhaps you want to mix and match your least favorite people and sports! Whichever you choose, apply the lessons you've learned so far and create some stick sports images of your own. Be sure you include yourself in the sketch with a sport you normally wouldn't be caught dead playing!

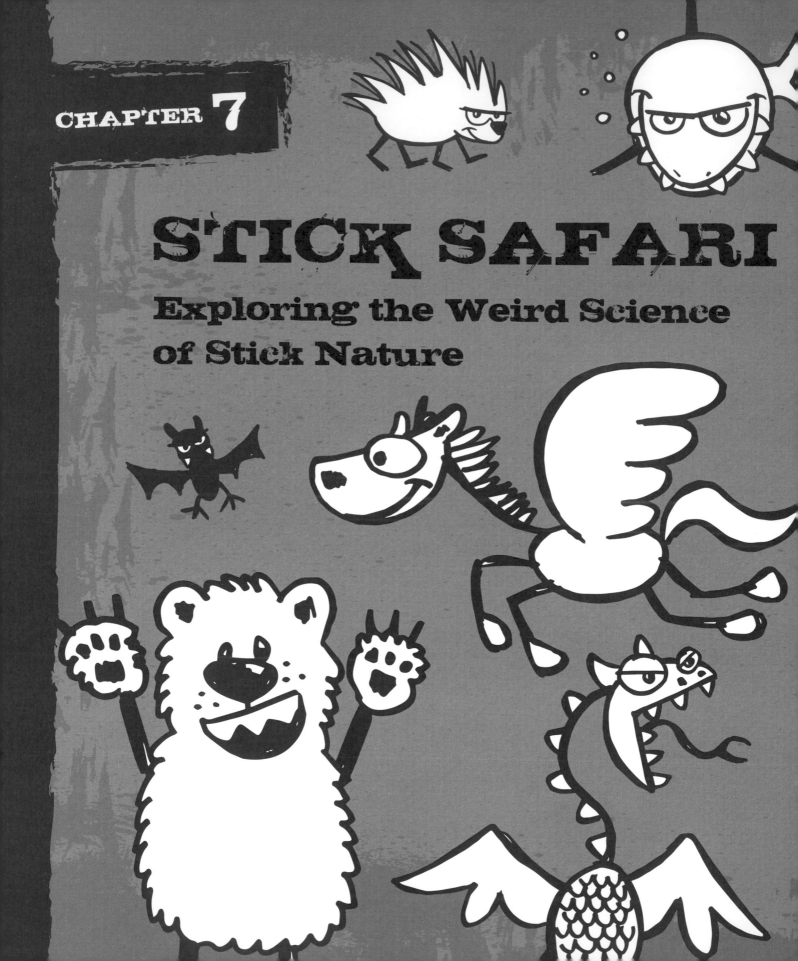

STICK SAFARI

Exploring the Weird Science of Stick Nature

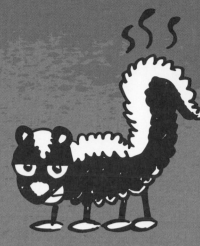

Welcome aboard, animal lovers! We have scoured the world to put together the most amazing stick animal safari. From Australia to Africa, we'll explore the many different genres of animals as categorized by our own personal stick science. So, if it's feathered, scaly, hairy, or slimy, you'll probably find it here. But before you start to nod off, don't worry—this isn't biology class! It's art class. And classifying and drawing a stick animal is a lot more fun. So, let's start dissecting!

In this chapter, we'll explore how the use of different textures can help identify specific animals, and we'll experiment with different techniques used to create them. Are you ready?

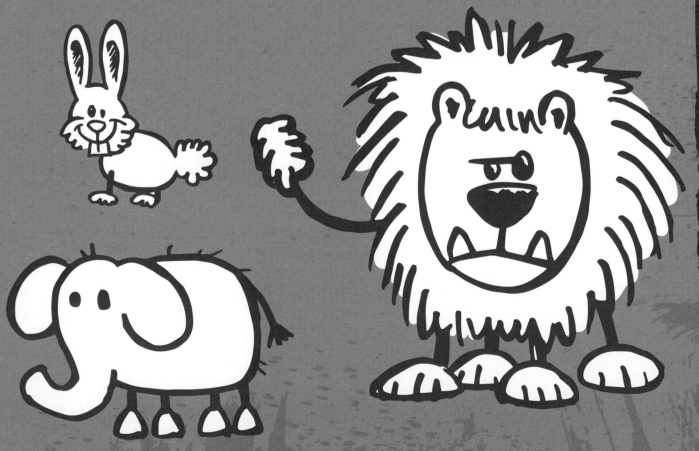

FURRY AND TEXTURED
Furrikus Hairibellicum

Welcome to the first leg of our stick safari, where we'll explore our furry and textured friends. Our first scientific family of stick animals is known as the *Furrikus Hairibellicum*. Why? Well, mostly because everything sounds way more important in a dead language like Latin, but also because this stick family includes most animals that have hair, furry bellies, and can be distinguished by their uniquely textured fur. Let's explore some of these animals and see some techniques we can use to distinguish their different textures.

Now, fur and hair come in a variety of different textures and colors, but our scientific stick geniuses have broken them down into three simple categories: the Fluffy, the Hairy, and Don't Touch Me! With the fluffy textures—like those of sheep or llama—we use a soft, billowy texture that is easily identified by rolling, curly-cue lines. On the hairy textures, we use quite a few different techniques, including zigzag lines, like those seen on a horse, lion, or giraffe mane, or the unfinished paint brush edging that you might see on a bear or bunny. And for the only-slightly hairy mammal, like a hippo or elephant, we've deployed the use of randomly placed hair follicle patterns that will remind you of a leg that hasn't been shaved in a few weeks. Lastly, we've reserved the Don't Touch Me category to identify animals that have a not-so-cuddly texture, including the porcupine, hedgehog, and even some of the spiny anteaters.

As you study the beautiful coats below, take close note of the techniques used to simulate the different textures and see if you can identify which category they belong to.

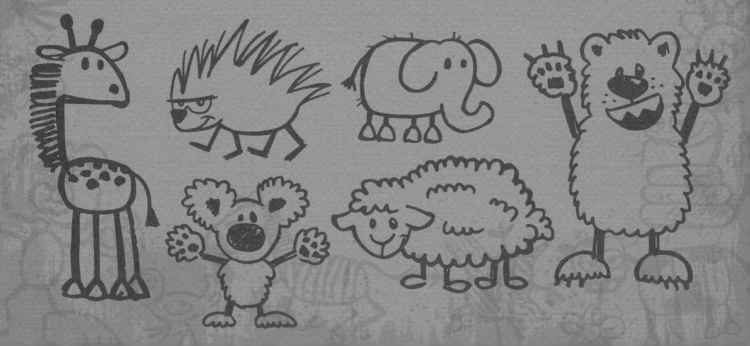

STICK
SKETCH SCHOOL
LESSON

Now it's your turn to get fuzzy with it! Try sketching your own dog or cat, or even the pet you always wished you had. What kind of fur or hair does he or she have? Can you capture your pet's attitude in a signature expression? When you're done, try drawing a whole zoo of other furry and fuzzy friends, practicing the different techniques used to create their furry coats and hairy textures. Feel free to go wild!

SCALY AND FISHY
Scalius Fishawquairrius

To the uninitiated, scaly animals and fish may sound like the same thing. But they most certainly are not! This is the stick animal family *Scalius Fishawquairrius*. What does that mean? It means it's special and fancy and if you were in an art school it would cost a lot of money to learn about it. See how lucky you are? This stick family includes snakes, sharks, dinosaurs, octopi, jellyfish, whales, and lizards of all sizes (and from any era).

As we look at some examples below, minimalism is important to keep in mind when sketching scales. In other words, just because an animal has scales, it doesn't mean you have to inundate their entire body with them. Too much of a good thing can busy up your illustration and weigh a poor fishy down, so try adding scales sparingly, in strategic spots only. As you can see below, an effective set of fish scales can be easily achieved by drawing connecting letter "U's" and staggering the rows. Lastly, when drawing fins, keep in mind that a little unfinished edge can make a fin look extra soft and flowy.

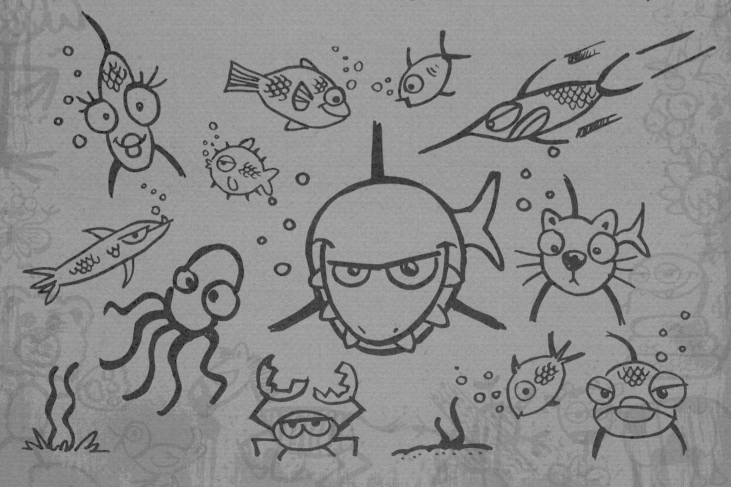

STICK
SKETCH SCHOOL
LESSON

Now it's your turn to tip the scales! Imagine you're fishing in a small boat, your line and hook are set below the surface of the water, and several fish are gathering around to check out the bait. What kinds of fish are there? Are they excited or curious about the bait? Or are they perhaps insulted by the slim selection? You decide!

SAY HELLO TO MY FEATHERY FRIEND!
Purtius Burrdicus

Basically, all birds or anything that looks like a bird, or has feathers (even a feather boa!), would fit here in the *Purtius Burrdicus* family. Yes, this category also includes some of the hard-to-define animals like the platypus (which sort of looks like an angry duck, right?). Remember, this is art, and looks are everything here! So, it doesn't have to actually be a bird; it need only look like a bird or have feathers to belong in this feathered family of stick animals.

As you examine these beautiful specimens below, can you identify the items that make them bird-like? Sure, wings, feathers, and beaks are obvious, but check out some of the smaller details, too. Sketching four-point stick feet can quickly help identify a stick bird, and using long stick necks and legs serves to connect the tiny torsos and heads. These are important elements that some people might miss when drawing their stick bird family. And once again, as you give your stick bird feathers, keep in mind that less is more. Strategically placed groups of feathers will give you the impact you need. There's no need to worry about your stick birds having enough feathers to take flight. These are stick birds, so they just need to look good—two or three short rows of feathers will do the trick. Similar to fish scales, feathers are easily achieved with the same letter "U"-shaped lines. However, you can also elongate them to create a more feathery feel.

STICK
SKETCH SCHOOL
LESSON

Now it's time for you to leave the nest! Draw some stick birds and feathered animals of your own. Imagine a flock of birds hanging out on a telephone wire together checking one another out. Perhaps they're all completely different birds from different parts of the world. Try to distinguish them by using some of the elements and techniques we discussed.

SCARY AND SLIMY
Skareeus Grossa Slymius

Think about the grossest creature you've ever seen: Does it scare you? Does it make you sick and disgusted to think about touching it? Ding! Ding! Ding! We have a winner! The creature you're probably thinking about fits right at home in the *Skareeus Grossa Slymius* stick family. Maggots, roaches, tarantulas, worms, killer bees, frogs, and rabid kindergarteners are all included on this safari of the macabre! You'll be sure to see lots of slime, fangs, long and hairy legs, and more on this particular tour, and no, we're not talkin' about your grandma's house!

Let's take a closer look at a few examples below, if you dare! Right away you see the angry eyes, which denote danger and strike fear into the hearts of enemies. But, also notice how the use of dripping slime helps up the cringe factor. Now, as you look at these specimens, ask yourself: Do you feel disgusted? Scared? Offended? Fantastic! We're moving in the right direction! Now you're in the perfect mood to create your own!

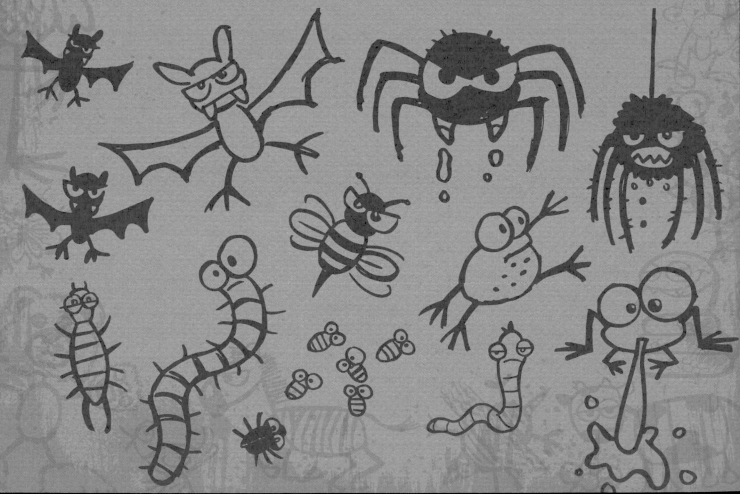

STICK
SKETCH SCHOOL
LESSON

Think of some disgusting experiences that you've had with other living creatures and draw on those for some inspiration. Perhaps you happened upon a pile of maggots in an unexpected place? Or you accidentally got caught up in the thick web of a hairy spider? As you draw some of your own gross stick creatures, make sure to include lots of slimy, drippy goo along with angry eyes and razor sharp fangs—exaggeration will help get the reaction you're after!

SPOTS AND STRIPES
Hardtu Ciforus Patterncus

Ooh, that's pretty! This stick family includes all animals with a distinct design or pattern. Zebras, cheetahs, and leopards fit nicely in this family, as well as Dalmatians, clown fish, and even cows. As you explore these multi-patterned stick animals below, examine the various degrees of line thickness used to create the detailed spots or patterns featured on them. What look do you prefer? Do you like filling in the spots and stripes with solid color, the kind of effect achieved with a thick paintbrush? Or do you prefer more detail offered by a thin pencil or marker? On this safari, you'll get a chance to appreciate both.

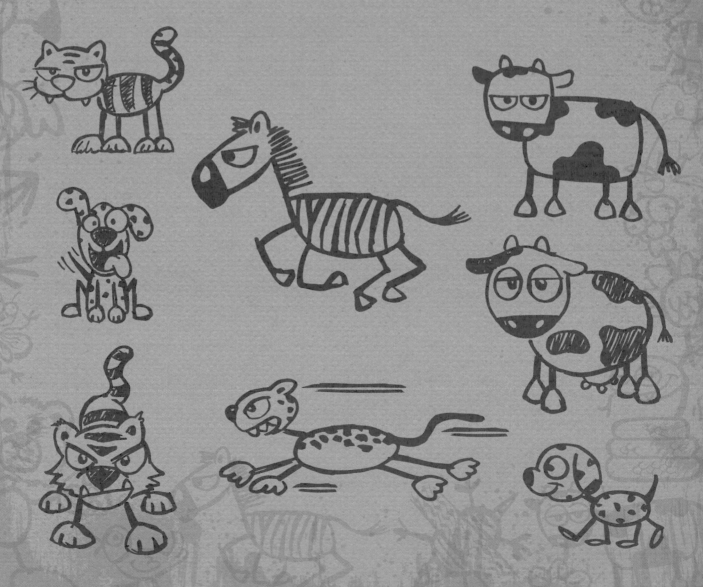

STICK
SKETCH SCHOOL
LESSON

Now, let's get this pattern party started! Try creating some patterned stick animals using the techniques in this chapter. Given the variety of patterned animals out there, imagine you're sketching an energetic zoo scene with zebras, cheetahs, leopards, and cows running wild. This is a good opportunity to experiment with different tools, so get pencils, markers, and even paintbrushes ready to create different effects with your patterns.

FANTASY AND CUSTOM
Makitup Asweegoiens

Sure, you've heard the stories about these fantastical beasts, but now it's time to bring the fantasy to life! The *Makitup Asweegoiens* is the family of stick animals that includes fantasy animals like dragons, unicorns, chupacabra, bigfoot, and pretty much anything with a myth or legend attached to it. We don't worry ourselves with pesky details like actual sightings. As long as you can see it in your mind, then we're A-OK!

Now, this family also includes hybrid animals, like the centaur, the griffin, and the infamous liger—which is a combination of two or more animals that forms a unique species. So, in this final safari lesson, we'll deploy that technique and turn you loose to create your very own customized stick animals.

For inspiration, check out some of these sweet, imaginary hybrid animals below and see if they inspire you. Do they look familiar? Are they out of this world? Can you think of some hybrid animal combinations of your own?

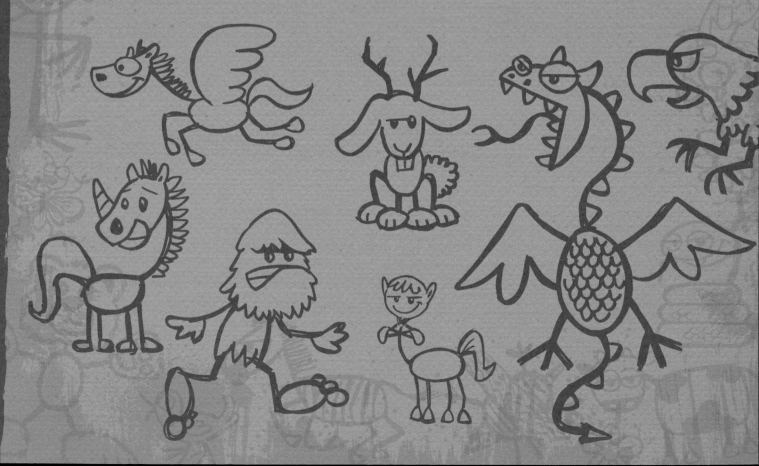

STICK
SKETCH SCHOOL
LESSON

All right, now is your chance to create your own stick species! The only thing that may hold you back is your imagination and, perhaps, the International Cloning and Ethics Committee. But for now, let's not worry about them. Go ahead and create some fantasy stick animals using your mind as a guide. Maybe combine some farm animals, like a chicken and a pig, to form two new species, including the "chig" and the "picken." Or, combine two animals from completely different habitats, like a polar bear and a flamingo, to create one new animal like the flamingo bear!

DOODLING THE DECADES

Sketching Pop Culture Icons through the Years

What defines an icon? Well, for our purposes, an icon is someone or something that has come to represent or symbolize a time or an era. In this chapter, we will explore American iconography from the 1950s to the present: From the King of Rock and Roll (Elvis) to the King of Pop (Michael Jackson); from Eisenhower to Obama; from Vietnam to Afghanistan; from the space race to the arms race. We will explore icons of language, music, culture, social change, films, and more. Icons are an artistic "gimme" when it comes to searching for inspirational examples to use and practice our skills in the stick medium; these ideas and the sentiments they embody are timeless. This lesson is an important one because an icon cannot be fully expressed in words the way it can be in art.

In this chapter, we will build upon the lessons in previous chapters as we try to re-create timeless collages that represent some of history's most classic eras. We'll not only focus on creating stick versions of the world's most recognizable and loved (or hated) people, we'll also mine for artistic inspiration by exploring some of the most popular items, symbols, and terminology from their given decade and combine them into creative collages. Are you ready? Let's get iconic!

THE 1950s
Icons That Were Cool, Daddy-O

In this chapter, we'll focus on the happy days of the 1950s, an era largely defined by the emergence of entertainment and the beginning of the space race. World War II was over, and everyone was ready to celebrate! Rock 'n' roll was born and taking the youth by their poodle skirts and leather jackets. All the while, the golden age of television was picking up steam, and the television set became a mainstay in the family living room. The 1950s also gave birth to some other wonderful staples of entertainment, including drive-in theaters, 3-D movies, and malt shops with jukeboxes. From James Dean to the sultry Marilyn Monroe, there was a seemingly endless plethora of young, emerging stars.

But it wasn't all just fun and games. The Soviet Union launched the space race with the Sputnik satellite, and the threat of nuclear war was always on the public mind, which made for a boon in the bomb shelter business, while schools were preparing generations of children to be ready to "duck and cover" from radiation and fallout.

Check out this 1950s-era collage below. Can you see how varying sizes are used to denote importance or significance? For example, notice the retro stars, which were a common pattern in this era and represented the public's fixation with space and technology. These simple stars can be achieved by drawing a letter "x" and a letter "t" right over one another. Try elongating just a few of the lines in each star to make them sparkle.

STICK
SKETCH SCHOOL
LESSON

Now it's your turn to be cool, Daddy-O. Draw as many popular stick people and elements that you can think of from this era and create a collage of 1950s pop culture. Be sure to alternate the sizes of each image to emphasize who and what were the most popular during this time. Also, try dressing a stick selfie in an era-appropriate outfit. And don't forget to monogram your initials on your clothing, as this was a popular fashion statement in the '50s.

THE 1960s
Icons with a Side of Peace and Love, Ya Dig?

The 1960s were a gas, as summed up by the Bob Dylan song "The Times They Are A-Changin'." The issue of civil rights, led by a charismatic young minister named Dr. Martin Luther King Jr., was on the forefront of the public eye. John F. Kennedy became president, launched a space race, and vowed to get our country to the moon while bringing us to the brink of nuclear war with Russia during the Cuban Missile Crisis. It was the decade when the United States went to war in Vietnam amid a sea of protesters; the golden age of muscle cars was upon us; and the Beatles led the British invasion that would change music history forever.

Okay, cool cats, take a look at the example collage below of the 1960s; there was a lot happening, man, ya dig? Do you see the turmoil, the war, and the peace? Can you feel the love? The '60s were "heavy," man, and being a hippy wasn't just a fashion trend. This collage is almost like finding some cool doodle page in the back of an old VW Bus, right? Whoa! Trippy… Okay, so while you analyze this hip collage, contemplate the words and phrases that defined this era and get ready to combine them with some iconic stick art.

STICK
SKETCH SCHOOL
LESSON

So, lay it on me, man! What's your image of the 1960s? Don't just focus on the stick people, man; try creating some accessories and other elements, too. Intermingle them with popular words and phrases from the decade and your collage should be out of sight!

THE 1970s
Dazed and Stickfused

Ah, the 1970s. A decade where the only things longer than men's hair were the bellbottom pants that were springing into mainstream fashion. Richard Nixon won the presidential election, only to resign the presidency because of the Watergate scandal. The Vietnam War was broadcast right into our living rooms. The country was thrust into a massive oil crisis when the United States was hit with an oil embargo that caused gasoline prices to skyrocket and forced gasoline rationing for the first time since WWII.

But the country never lost its sense of humor, as an upstart live-comedy sketch show first called out to the nation, "Live from New York, It's Saturday Night!," and young adults were "Staying Alive" while boogieing the nights away to disco music. Star Wars was born, and other blockbusters, like Jaws and The Exorcist, were scaring us at the movies, while terrorists scared us in real life as more than 50 American citizens were taken hostage at the U.S. Embassy in Iran.

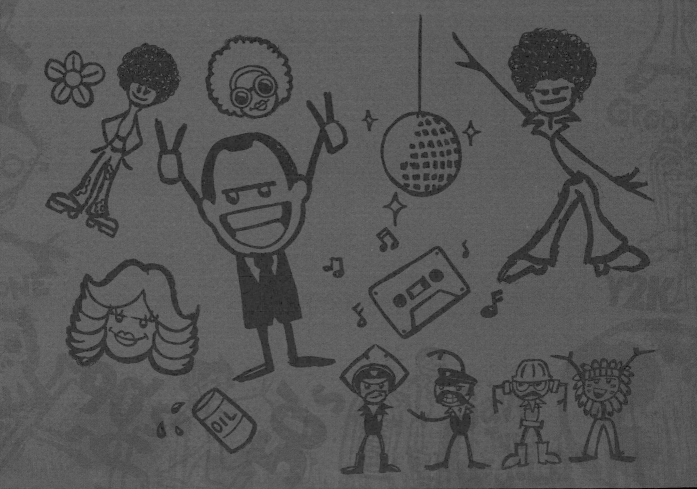

STICK
SKETCH SCHOOL
LESSON

All right, it's time for you to get down with your own ideas. So what's your image of the 1970s? Combine stick people, words, and other elements from this decade into a cool collage that will have you and your friends wanting to boogie all night. Choose a theme from the '70s (music, major events, or TV shows) and draw your own collage.

THE 1980s
Like, Totally Awesome Icons!

While the 1980s are known for the eccentric hair and fashion, the decade also brought us amazing technology and introduced us to an era of materialism never before seen (remember the occasional "car phone" that was about the size of a small child?). Suddenly, the hippies of the 1960s had become the yuppies of the 1980s.

In sports, Michael Jordan rose above the competition and made shoes more valuable than gold, while another MJ became the King of Pop and thrilled the masses with his music. We witnessed the birth of MTV, where we could actually see music come to life in the form of videos. And, speaking of videos, now everyone was able to record and watch movies at home with the arrival of the first VCR! Kids also discovered a new addiction as video games exploded onto the scene, dominated by the arrivals of Atari and Nintendo, while a tiny upstart company named Apple would change the way we lived and worked with the introduction of the Macintosh.

With entertainment becoming so popular, it seemed only appropriate that an actor was elected to the Oval Office. And while Ronald Reagan survived an assassination attempt, musical legend John Lennon did not. Tragedy also struck when the space shuttle Challenger exploded just moments after lift-off.

Okay, don't gag me with a spoon! Like, take a look at our totally radical collage example below of 1980s icons and ask yourself, "Like, what is soooo awesome?" Is it the clothes or, like, our totally big hair?

STICK
SKETCH SCHOOL
LESSON

So, what's your image of the '80s? Draw as many elements and words as you can think of and create a collage of pop culture from this decade. Imagine you have Saturday morning detention at your high school library and you are an '80s teen bored out of your mind. What would your doodle page look like? Are you into music, current events, movies, or fashion?

THE 1990s
Icons? Yeah, Whatever.

While a bunch of Beverly Hills teenagers were adjusting to their new zip code (90210), a group of "Friends" in Manhattan moved in alongside their neighbor Jerry Seinfeld at the top of the TV ratings for the better part of the decade, impacting everything from fashion and hairstyles to catch-phrases and Seinlanguage. But it was a ten-year-old boy and his animated family from Springfield who would go on to become the stars of the longest-running show in television history, *The Simpsons*.

In music, hip-hop went mainstream as the spotlight shifted to the disenfranchised music scene of Seattle, and soon the term "grunge" would become more than just music but a way of life. The 1990s made depression and anger cool for a time. Yet, even as the doom-and-gloom culture of grunge spread with the tragic death of Nirvana's Kurt Cobain, the sun began to shine a bit brighter as people began to care about the environment again. Environmental groups became extreme as did our sports—the X-Games were born, and skateboarding evolved from a crime into a legitimate sport. And even though people started to care more about the outside, they began to spend more time inside, as we ushered in the dawn of the Internet age. AOL came online and before you could say "You've Got Mail," they became the dominant Internet provider.

In politics, George Bush (Senior) escorted us into the Gulf War in Iraq, while a saxophone-playing governor from Arkansas—Bill Clinton—welcomed a new era of economic prosperity for the country, but achieved notoriety for his, er, unprecedented internship program.

Okay, the history lesson is over. It's time to put on your flannel shirt, ripped jeans, and combat boots, and get to work. Take a look at this collage below of '90s icons. What other events and icons do you think of when you think of this era?

grunge

TECHNO

STICK
SKETCH SCHOOL
LESSON

So what images do the 1990s conjure up for you? Try creating your own collage, drawing from as many people, events, and elements from this decade. Alternate the size of elements to denote importance, and sprinkle in a few key catchphrases to finish it off. Or, if you want to try something more specific, sketch a stick crowd at a Pearl Jam concert. There are stick figures moshing, Eddie Vedder is crowd-surfing, and the audience is a sea of flannel shirts as far as the eye can see.

Y2K TO 2DAY
Your Life in Stick Art

The 21st century has ushered in a new era of technology and modern science, but it wasn't all so warmly received. In fact, as New Year's parties everywhere blared Prince's "1999," many held their collective breath wondering if the world's communications were going to collapse from the over-hyped Y2K computer glitch. We all calmed down until the 9/11 terrorist attack and the name Osama Bin Laden would become a staple for our news headlines for over a decade.

As our views on health and environment continued to evolve, so did the Internet, where we started "Googling" and "hashtagging" our words into #long #unreadable #gibberish. Computer networks were replaced with social networks, and people tweeted from mobile touch-screen devices dominated by Apple's iphone.

TV saw just as radical a shift as shows went from being beamed to streamed, and the introduction of reality TV saw actors unceremoniously dumped in favor of just about anyone who was willing to air their drama for fifteen minutes of fame. But it wasn't all reality as franchise movies became the norm, and we were introduced to hobbits, superheroes, and an animated giant named Pixar, who helped us keep our head in the clouds.

Economically, we were forced to rethink our priorities, as we witnessed the Great Recession and the collapse of the real estate market. Politically, we saw the first African-American president, and technologically, we landed a rover on Mars.

So as we continue to write history, take a look at the collage below. Does it look familiar?

STICK
SKETCH SCHOOL
LESSON

Okay history is history. It's time for you to visit the present and create your own stick collage, drawing on people and events in your current life as inspiration. What really sticks out to you? Tell a visual stick story of your life using people, places, events, and words. And remember, you are what you draw!

STICK MUSIC SCHOOL

The Sticks Are Alive with the Sound of Music!

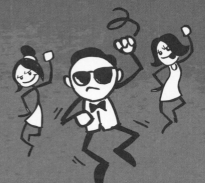

So let's drop some beats and let our imaginations fly! No matter what type you prefer, music is an art form chock-full of inspiration from a plethora of amazing artists—from the elaborate costumes and funky hairstyles to the amazing set and design work featured on concert tours, videos, and even album covers. Yes, art and music have been partners since Rock found Roll, Hip friended Hop, and Country first said "howdy" to Western. And while the music and the names have changed over the years, the results have remained largely the same: music continues to shape our pop culture, fashion, and trends. These are the details we're going to focus on as we bring art and music together to create beautiful stick music.

Now, you can easily add lots of floating musical notes to any design to visualize music, but in this lesson, we'll delve deeper into the culture of several music genres and use some fun techniques to re-create your favorite musical stick figure bands and artists. And since we couldn't possibly cover every music type and genre in this book, we'll let you loose to forge your own rhythm and find your own sound with stick people that will conform to the music you crave. Are you ready? Turn on your tunes and let's rock!

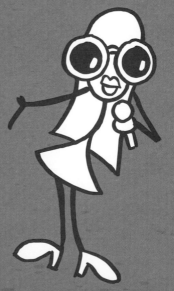

IT'S ALL ROCK 'N' ROLL TO ME
Listen Here, Punk, Either It Rocks or Not, There's No Alternative!

Crank up the amp, and plug in your Les Paul because it's time to draw on all music that rocks! (Insert scream and guitar riff here.) Since there have been so many different forms of rock throughout the years, we won't focus on the differences in styles between rock 'n' roll, punk rock, alternative, or metal, but will celebrate the similarities instead. Let's get started!

As you rock out to your tunes, take a look at the art below and consider the attributes that make stick rock unique! The wild hairstyles, defiant attitudes, dark and over-the-top outfits studded with metal jewelry, and platform boots complement the obscenely loud, electric instruments and screaming, out-of-control fans, who all help to make the different rock genres one big rebellious family.

Wild is as wild does, so to create rockin' hairstyles, we have only one rule: go crazy! Wildly and randomly scribbled lines and crazy circles can give you the wild rock star hair you desire. Whether it's long, short, fro, or Mohawk, don't be afraid to create a random mess! When it comes to the instruments, you can make noise with just about anything, so you can't go wrong here! For guitars, pick any shape, like a triangle, a pear, or even a diamond, and simply add a long line for the guitar neck, and you're there! Of course, don't forget to top off your rockers with those insane outfits, including leather pants, spiked collars, and metal boots! Look for some inspiration in the stick rockers below.

STICK
SKETCH SCHOOL
LESSON

Are you ready to ROCK? Step onstage and sling on your pencil; it's time to capture the essence of rock with your stick art! Pick your favorite rock star or group and sketch them wailing away on a guitar, pounding the skins, or screaming into the mic! There should be lots of action here, so make sure to show it with wild head-banging hair, fist pumping, stage-diving poses, and tons of action lines and musical notes flying all around.

THE ART OF HIP-HOP
Keepin' It Real, Fo' Shizzle!

Get your turntables loaded and your MC to the mic 1, 2; it's time to cut, scratch, and rap our way to a hip-hop stick crew. While hip-hop has certainly gotten a bad rap over the years, there's no denying its mainstream popularity, and its substantial impact on pop culture, sports, and fashion. So, whether you're down with old-skool rap or today's modern G's, let's flip on your favorite tracks and get inspired as we explore the art of hip-hop, stick-style.

Cha-check out the examples below! Notice the sweet poses and accessories that have become synonymous with hip-hop culture? We're talking about things like hoodies, beanies, and backward caps to go along with the dazzling bling, cars, headphones, turntables, and mics! They're all the rizzle dizzle in the stick world. But what really sets this hip-hop art apart from the rest are the poses that always seem to be coming right at you! We can emulate this look by creating depth in our stick figures. The key to sketching depth is to draw certain elements, like heads and fists, oversize, while shrinking the rest of the body so it appears farther in the background. We call this the 3-D effect! Booya!

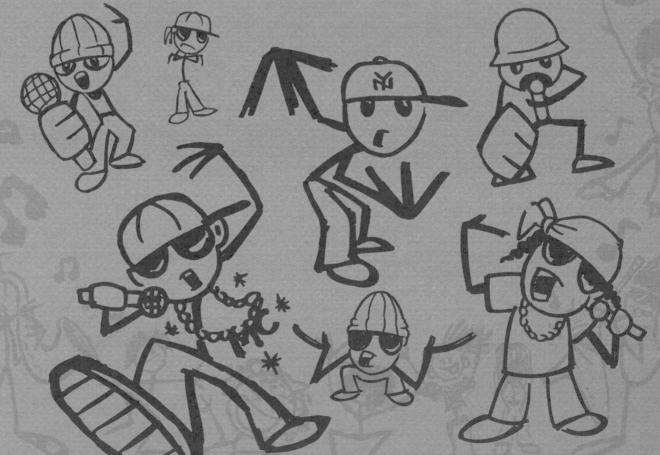

STICK
SKETCH SCHOOL
LESSON

Okay, DJ, it's your turn! Are you ready to lay down the beats and take a pencil to some sheets? Create your own hip-hop scene using the 3-D effect. Imagine that your stick figures are creating a music video on the streets of New York, LA, or some other large city. Create a whole group, including one or more vocalists on the mic, a DJ spinning records, and a whole entourage of their hooded stick peeps dancin' and posin' it up in the background. What other elements can you envision in your video to really bring the hip-hop style to life?

STICK MUSIC SCHOOL: The Sticks Are Alive with the Sound of Music!

121

POP MUSIC
Creating the Pop to Put Your Artist on Top

Pop music (short for Popular Music, of course) is a genre through which artists are made, and not necessarily discovered. In fact, what qualifies as "popular" music doesn't necessarily equate to good music, but that's a matter of opinion. While some artists, like the King of Pop, Michael Jackson, have proven prolific in this area, others have had their one-hit wonders and are gone before you can say "Gangnam Style." In summary, a successful pop artist usually has something that makes them "pop." No, we're not talking about talent; we're talking about a little thing called a "gimmick." Whether it's a funky new dance craze, a shock-rocking ritual, like spitting fire, or even a flashy or elaborate costume that makes you go gaga, pop music can certainly draw a crowd. Big budget music videos and catchy tunes that you can't get out of your head are the trademarks of pop music, and they'll be our focus of inspiration in this lesson.

So, let's get gimmicky! With all of the provocative outfits, makeup, hair, shoes, stages, and ridiculous dance moves seen in pop music, there should be no shortage of inspiration here. As you look at a few examples below, consider the actions of some pop artists in your generation and how you can illustrate their gimmicks. Focus on their movements and poses and try to copy their smooth dance moves. Sometimes performing their moves in the mirror can help. Of course, the gimmick doesn't have to be a dance. Maybe they're blowing fire, breaking their guitar on stage, or even swinging from the ceiling on a trapeze. What sets them apart? What gives them the "pop" that puts them on top?

STICK
SKETCH SCHOOL
LESSON

Now pop in some bubble gum to get you in the mood, because it's time for you to strike a pose and create your own stick pop diva. And guess what? She's dating a guy in the hottest new boy band. Try sketching the band performing onstage. As you sketch them, focus on their unique dance moves or other gimmicks that turned these artists into stars, and see if you can get that across in your art. Use examples on the previous page or real-life pop stars for inspiration here!

STICK MUSIC SCHOOL: The Sticks Are Alive with the Sound of Music!

123

COUNTRY 'N' WESTERN
Letting Your Stick Figures Grow Up to Be Cowboys

For many, country isn't just music—it's a way of life! Of course, there are several different subgenres within country music today, but country in general has a reputation for recounting the sad stories of broken hearts and lives, all accompanied by that trademark country "twang." So today, we're gonna "cowboy up" and see if we can wrangle in some of that culture to create some original country western stick art.

Let's take a look at some stick country examples below. But it's not just about ten-gallon hats and cowboy boots, is it? Yup! It sure is! The quickest way to cowboy-up a stick figure and turn them into a country superstar is to outfit them with a big ol' hat! A cowboy hat can be easily achieved by drawing a double-backed letter "m" with a smiley face under it (see example below). Once your country star is outfitted with a hat, you can finish off the outfit by addin' some boots, a bandana, a fringe-lined jacket, and a whole bunch of sparkly glitz-and-glam stars, because those country divas love to shine!

The last thing you'll need to do is to equip your country stars with the tools of the country trade. We're talking accessories like gee-tars, banjos, fiddles, harmonicas, and even a washtub bass. Finally, throw them in a rural farm setting with some hay, barns, pick-up trucks, tractors, bull ridin', and horses, and you've arrived!

STICK
SKETCH SCHOOL
LESSON

Yee haw! Are you ready to two-step your way through this lesson? Round up that paper and try to rope in these little doggies. Give a howdy to the elements we have reviewed as you re-create your own stick country-western guys and gals.

STICK MUSIC SCHOOL: The Sticks Are Alive with the Sound of Music!

125

JAZZ AND THE BLUES
Creating Sax Appeal in Your Instruments

When it comes to jazz, you can't just play it; you have to live it! And in order to do that, sometimes you have to get your heart stomped on until the blood flows out of your fingertips and into your instrument, while your searching soul finds its voice and sings aloud! Sounds painful, I know, but jazz is quite the opposite. Even though the music has evolved over the years, the things that have remained constant are the instruments of choice. In fact, many of the instruments used in jazz are the same ones used in today's marching bands—classic brass instruments, like the saxophone, clarinet, and trumpet. These brass instruments can easily be drawn with a line to simulate the body of the instrument with a triangle or cone added to the end for the detail. Check out some of the examples below.

As we explore the look of our band, we have to consider the legends of jazz and blues, like the great Louis Armstrong, Dizzy Gillespie, and Thelonious Monk. They had more than just soul; they had style, and their music gave birth to its own unique fashion in the form of fedoras, shades, and classy suits that evolved into berets and facial hair like the goatee, or the "soul patch" as it came to be known. A goatee can be added with just a simple stroke or scribble on the chin, just below the mouth.

STICK
SKETCH SCHOOL
LESSON

Now, dig down deep and find your musical soul because it's time to jazz-up a stick band of your own. Create a regular stick band with the classic brass instruments and then slowly transform them into a jazzy blues band by adding all of the cool fashion accessories, like fedoras, shades, and soul patches. And don't forget to include lots of musical notes and action poses.

STICK MUSIC SCHOOL: The Sticks Are Alive with the Sound of Music!

127

THE ULTIMATE PLAYLIST
What's Shuffling through Your Ears?

"Who do you love?" an artist once sang, and now we are asking you that same question. What other styles of music do you love? R&B? Dance? Oldies? New Wave? Dub Step? Electronic? World? Reggae? What do the trends look like from your favorite style of music, and who are some of your favorite musicians from that genre? Here, we are going to put to use all of the lessons from this chapter as we focus on identifying what details we can use to create stick figures that portray our very own favorite musical artists.

The first step is to identify your favorite group or musician. Next, identify what about them stands out? Is it their funky hairstyle or their outrageous outfits? Perhaps they have some distinctive features, like a certain dance move, a special hat, a uniform, unique tattoos, or interesting facial hair? Filling your stick figures with those recognizable details is the key to bringing your stick musicians to life!

Let's review some more stick music examples below from other genres. Can you recognize whom they are emulating based on their distinctive features? Hairstyles and facial hair are typically a great place to start! Perhaps it's just some rough stubble, which can be achieved with a series of dots to the chin, cheeks, and upper lip. This same dotting technique can also be used to portray a shaved or half-shaven head, like you might find with a punk rock band. But in the end, the details mentioned above will likely dial in and define your stick character and make them immediately recognizable.

STICK
SKETCH SCHOOL
LESSON

Okay, it's time for you to make some music! Imagine you are filling the stick stage with a fantasy supergroup comprised of your favorite musicians. If you are in need of ideas, perhaps you can emulate music legends who died too young, like Bob Marley, guitar legend Jimi Hendrix, '90s grunge rocker Kurt Cobain, and bluesy '60s vocalist Janis Joplin. Anything goes, so don't be afraid to mix in other genres, too, like adding Beastie Boy Adam Yauch, flanked by hip-hop artist Tupac, and turntable instrumentalist Jam Master Jay! Suddenly your stick band is off the charts! And remember, no concert is complete without a screaming mosh pit of crazy stick fans!

STICK MUSIC SCHOOL: The Sticks Are Alive with the Sound of Music!

THE STICK WARS

Drawing the Art of Stick War

"To know your enemy, you must stick it to your enemy."

—Stick-Tzu, *The Art of Stick War*

What is stick war? Stick war is an-every-man-for-himself battle royale where each player takes turns drawing different stick warriors and creating new ways to attack his or her opponent. It's a great way to create action-packed stick drawings with friends.

Now, like any war, there are no real winners in stick war, only stories to be told—stories of heroism, honor, glory, and courage. But in the end, you will be left with an amazing, creative stick war drawing! And as you draw, stick war will test your bounds of versatility, wit, vision, strategy, and skill, for it is a game born out of necessity where mortal enemies band together to fight a common foe: BOREDOM! So, whether you're in an extended class lecture, stuck on a long journey, or just looking for something to do on a rainy day, there is always plenty of action to be found in drawing a stick war!

WHAT YOU WILL NEED FOR EACH CHAPTER

- A Battle Location: Any piece of paper, clean or scrap, will do.
- A Drawing Weapon: A pencil, pen, or paintbrush will do. Now you don't have to use a pencil, but newbies often feel more comfortable knowing they can erase their mistakes. But go for whatever makes you feel most empowered, soldier!
- A Willing Opponent: You can play by yourself or with friends. Just be aware that drawing a stick war battle alone may cause loved ones great concern for your mental state.
- Rules of War: Rules? There ain't no rules, just a few simple steps.

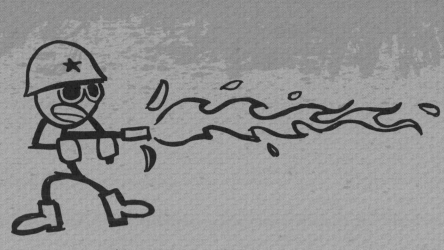

STEP 1: SET THE LANDSCAPE

Draw a cool backdrop for your battle. What is your ideal setting? Are you in space, on earth, or deep in the ocean? You can draw a simple horizontal line for ground or you can create a rocky surface, a grassy surface, a water surface, etc. Feel free to dress it up with details like trees, rocks, cliffs, craters, and more if you want to really spice up the landscape.

STEP 2: DRAW YOUR WARRIORS

Player 1 begins the battle by drawing the first warrior.

STEP 3: ATTACK!

Player 2 then takes a turn by drawing one of their own warriors attacking Player 1's warrior. Each player continues taking turns, drawing one new warrior and one new action per turn—that action can either be an attack or a defense, like blocking, teleporting, or creating a force field.

Now, before you begin, you have to get geared up for battle by deciding what kind of warriors to take to battle. Keep in mind that you are only limited by your imagination. You can re-create a real historical battle like one in World War II, or you can fight a battle from one of your favorite movies, like *Star Wars*, *The Avengers*, or *The Hobbit*. Deciding on the battle will help you choose the appropriate warriors to draw. You can create classic warriors, like ninjas, Spartans, or even Jedi knights, or you can go completely crazy with wrestlers, zombies, or even monsters. Whatever you decide, make sure you have plenty of drawing space on your paper, because the bigger the paper, the bigger the war!

So, are you ready to practice the art of war? Let's do battle!

STICKS OF DUTY: MODERN WARFARE
Modern War for a Modern World

In this lesson we will examine many unique ways to annihilate your opponents using modern weapons and war machines from WWII to the present. Whether it's the stick marines storming the beaches of Normandy or a group of Navy SEALs parachuting into battle while fighting pirates on a ship, this lesson in conventional stick war will be filled with lots of advanced weaponry options, like flamethrowers, rockets, tanks, helicopters, jets, ships, and drones.

Ready to Fight?

STEP 1: THE LANDSCAPE

Okay, let's set the backdrop. Are you in the realm of WWII and the cities of Europe, or in the jungles of Vietnam with the 101st Airborne Division? Perhaps you just want to battle against the forces of boredom by creating your own modern war based on a recent movie or game? Whichever setting you prefer, some modern warfare backdrops to consider are everyday settings you see all around you, including beaches, mountains, forests, jungles, and even frozen tundra.

STEP 2: THE WARRIORS

While many of us are familiar with the images of today's modern soldier, the truth is, most of our "real world" fighting experience is probably limited to video games and those little green army men we had as kids. So, let's start there as we try to imagine what our stick soldiers are going to look like. Conventional warriors can be as simple as drawing an army helmet on your stick figure (see facing page). But if you want to get more detailed, you can create details to match the location of the battle. For example, if you are in the classic jungle, you may prefer traditional camo and boots. In the snow, you may want to just keep the uniforms white, but bundle them up with jackets, boots, and a little fluff for warmth. Underwater? You're going to need to draw some gear like flippers on the feet and oxygen tanks on the backs. Whatever look you decide on, be sure to distinguish your stick forces with a unique logo or markings. After all, you want to eliminate any friendly fire incidents.

STEP 3: ATTACK

Atten-tion!! Okay, soldier, here are some stick soldiers and weapons for you to check out before you go to battle. See anything that catches your fancy? Don't worry, you don't have to choose one; you can incorporate ALL of them into your stick arsenal.

As you can see, there are more weapon options than you can shake a severed stick arm at, so have at it! Get geared up and hit the battlefield to create your own modern stick war!

NINJA WARS
Master the Art of Stick Fu

Few warriors are as stealthy and crafty as the ninja. In addition to being martial arts masters, these silent figures are also masters of the sword, long staff, nunchakus, and, of course, the throwing star. Let's put your stick figure art skills to work and capture some sweet stick fu action poses in our first stick war.

Ready to Fight?

STEP 1: THE LANDSCAPE

First, you must establish the terrain. Literally. Where do your ninjas fight? If you are in Japan, maybe try drawing Mount Fuji in the background or adding some Japanese-style buildings with curved roofs. Feel free to turn up the difficulty by adding two cliffs on each side of the paper, separated by a deep chasm. The possibilities are endless.

STEP 2: THE WARRIORS

Of course, ninjas are well known for wearing their masks. So, to create a stick ninja, simply draw a sideways oval in your stick head with two eyes showing. But what are some other ways to distinguish your army of ninjas from your opponents? You can try adding unique features, like a sword slung over the back, a headband or belt, or the unique ninja-style split-toed boots. One very popular method is to use a unique insignia or logo to mark your army. For this stick war lesson, let's keep it simple and we'll battle with the black ninjas versus the white ninjas.

STEP 3: ATTACK

Okay, now it's your turn. Once you've designated the terrain and selected your warriors, you can begin your stick fu ninja war. Start by having either you or your opponent draw a warrior and then have the second player attack them. Continue taking turns until you run out of time, paper, or patience. Take a look at some of these unique warriors and weapons below for inspiration.

BAM!

SWOOSH!

135

THE WAR OF THE RINGS
Going Medieval for the Precious

Knights, dragons, ogres, elves, dwarfs, and more fight for supremacy of Middle-earth in this Tolkien-inspired scenario of fantasy warfare. Only your imagination can limit the world you create. Find an opponent and take turns using these fantastic magical elements to fight each other.

Ready to Fight?

STEP 1: THE LANDSCAPE

Castles, mountains, swamps, dungeons, mystic forests…it's all welcome here! What do you have in mind? Sketch the background of your choice.

STEP 2: THE WARRIORS

Fantasy war offers a wide selection of different warriors and unique fantasy weaponry. Check out the hints below for details on how to re-create these different warriors. Do you prefer the traditional armored knights of man or perhaps the enchanted archery of the elves? Maybe you're feeling like a bad guy today and prefer an army of orcs, goblins, or trolls? Of course, there's always the magic of the wizards. But if you want to go really crazy you could integrate creatures like dragons, wraiths, or even living, breathing trees! C'mon, it's fantasy! Anything goes when you have magic!

STEP 3: ATTACK

So it begins! It's time for you to take up arms, your stick arms that is! Start your fantasy war and let your artistic mind soar. In this fantasy war, try alternating through the assortment of different warriors and weapons on the facing page and see where the battle takes you. What unique elements can you attach to your stick warriors to tell them apart?

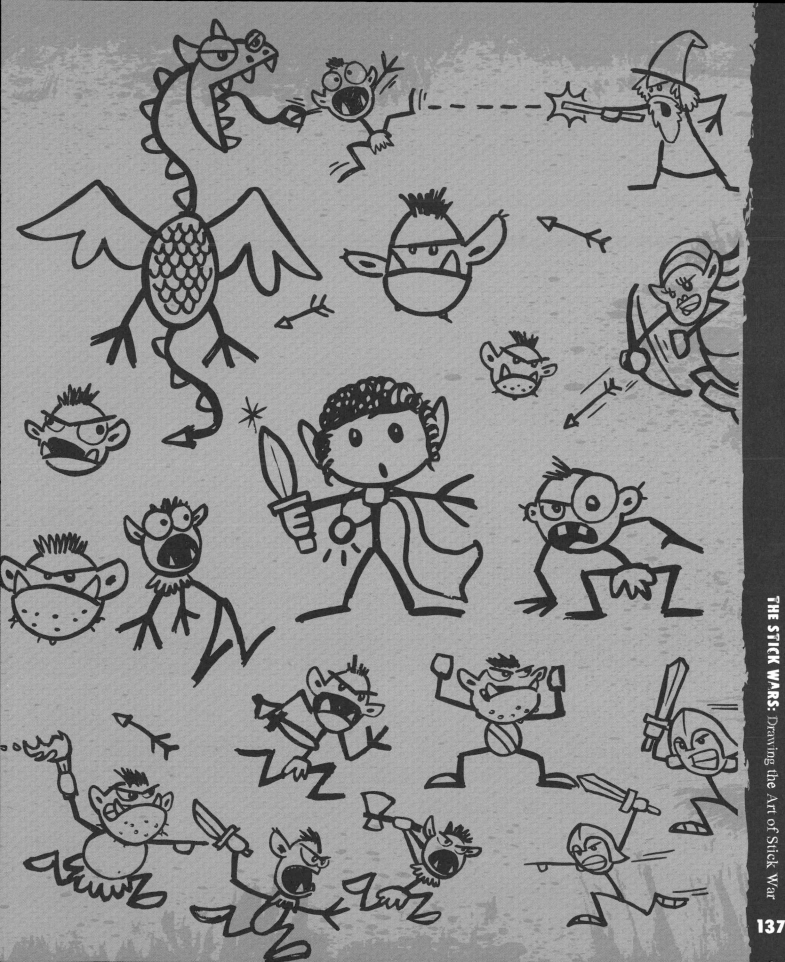

THE STICK FIGURE STRIKES BACK

In A Stick Galaxy Far, Far Away

Luke Stickwalker, Stick Solo, Princess Stickla, Stickbacca, and the rest of the Stick Alliance battle the evil forces of the Galac-stick Empire, including Stick Vader and his Stick Troopers. But with the help of Luke's mentor and teacher Obi Stick-Kenobi, the Rebels have the Force on their side and are sure to come out on top. Find an opponent and get ready to recreate your favorite Stick War battles.

Ready to Fight?

STEP 1: THE LANDSCAPE

So, where is the battle going to take place? Deep Space? The Stick Death Star? The deserts of Sticktooine? Again, the basics for the backdrops are fairly obvious: space stations, asteroids, planets, stars, spaceships, rocks, deserts, and dunes all provide great inspiration for backgrounds to begin your battle.

STEP 2: THE WARRIORS

It's the classic war of good versus evil, and YOU are the master. You must choose your side and create your fighters. Take a look at the drawings on the facing page for inspiration on how to re-create stick versions of your favorite characters and may this FARCE stick with you!

STEP 3: ATTACK

Okay, it's time to free the galaxy—or take it over—depending on which side you've chosen. Check out the weapons represented on the facing page for inspiration and get ready to battle. Choose your landscape, select your warriors, and attack!

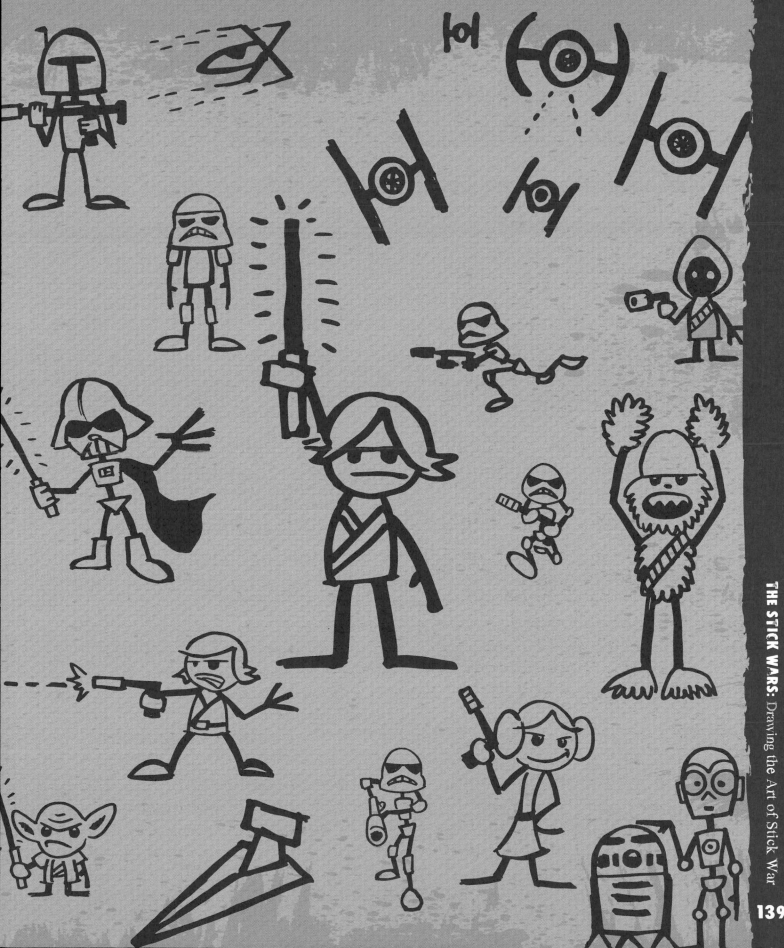

HEROES VS VILLAINS
A Super-Powered War of Good vs Evil!

Holy Toledo, stick man! The stick world is in peril and you must choose sides! Will you join Captain Stickmerica, Iron Stick, and the rest of the Stickvengers as they fight the evil forces that seek to use their super-erasing powers to rub out the stick people of Earth? Or will you join the dark forces led by the evil geniuses Stick Joker, Stix Luthor, and Stickneto? Find an opponent and create a superhero stick war using stick heroes and stick villains with the most super elements that you can imagine.

Ready to Fight?

STEP 1: THE LANDSCAPE

A major metropolitan cityscape like New York is a perfect landscape for this! But any big city with tall buildings and innocent people will provide a great place to let good and evil duke it out. As you choose your location, keep in mind that you can depict any place in the world by including a major world landmark in the background, like the Statue of Liberty, the Pyramids of Giza, or the Eiffel Tower.

STEP 2: THE WARRIORS

Caped stick fighters, masked crime spree-ers, flying figures, or water-dwelling warriors are just some of the ideas you can use to create your crew of good or evil. Note: Capes can be easily created by adding a triangle shape to the back of the neck of each character. See the super stick heroes for inspiration on outfitting your hero and then create your own super stick heroes!

STEP 3: ATTACK

Okay, it's time to save the world! But how will your heroes and villains manifest their superpowers in art form? There are lots of options. Maybe you can draw your stick hero flying in the air, shooting a laser from his or her eyes, or lifting a car with superhuman strength. What else can you come up with? Let's find out. Ready? Wonder Stick Powers activate!

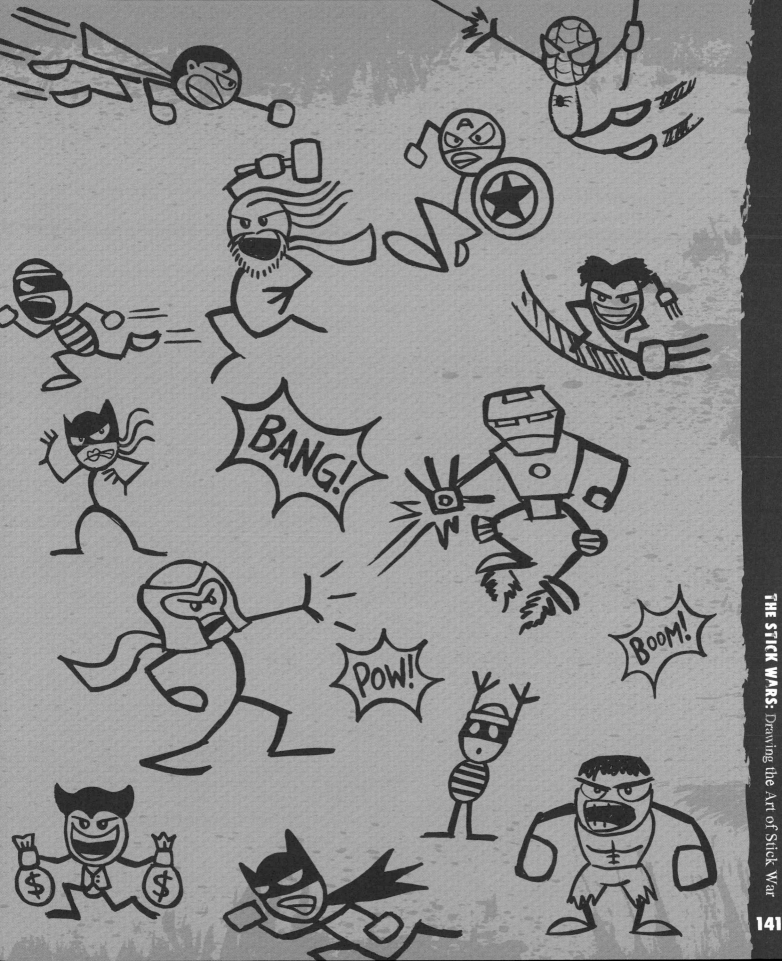

BANG!

POW!

BOOM!

STICK BATTLE ROYALE!
Putting the "Mix" in Mixed Martial Arts

Okay, the gloves are off! In this trailblazing lesson, we will abandon all conformity and rules that limited us to a specific time, place, or theme and have a free-for-all style war. Your imagination will be your guide! Drawing on all of your training from this chapter, you and your opponent(s) will battle using any style of warfare to create the ultimate stick battle royale. But—and this is truly where the "no rules" part of stick wars really reaches its apex—you are not bound by any of the specific classes of warfare covered in this chapter. In fact, you don't have to use any of them, unless you really want to.

Now, when we say "free-for-all," we really mean it. Anything goes! And while you consider what to do with your newfound freedom, get inspired with a few outrageous mix-ups and mismatches to put you in the proper mood. Imagine some fights like these:

> Cowboys vs. Ninjas (Sheriff stars vs. Ninja stars)
> Jocks vs. Nerds (The ultimate revenge)
> Zombies vs. Politicians (Who can tell them apart these days?)

Ready to Fight?

STEP 1: THE LANDSCAPE

Mount Rushmore, the Moon, Sesame Street, or Congress, whatev! Any place you can imagine is where you will fight!

STEP 2: THE WARRIORS

We're not going to lead you this time! You have earned the right to lead the fight. Now go and build your own unique army of stick soldiers! Who would you choose to fight on your team? Zombies? Athletes? Celebrities? Relatives?

STEP 3: ATTACK!

Okay, Armageddon is here, and it's time for you to bring the Stickpocalypse. Think outside the box and put together the most unique stick war you can imagine using anything and anyone as inspiration!